THE 50 GREATEST PHOTO OPPORTUNITIES IN NEW YORK CITY

Amadou Diallo

Course Technology PTR
A part of Cengage Learning

COURSE TECHNOLOGY
CENGAGE Learning

Australia, Brazil, Japan, Korea, Mexico, Singapore, Spain, United Kingdom, United States

COURSE TECHNOLOGY
CENGAGE Learning™

The 50 Greatest Photo Opportunities in New York City
Amadou Diallo

Publisher and General Manager, Course Technology PTR:
Stacy L. Hiquet

Associate Director of Marketing:
Sarah Panella

Manager of Editorial Services:
Heather Talbot

Marketing Manager:
Jordan Casey

Executive Editor:
Kevin Harreld

Project Editor/Copy Editor:
Cathleen D. Small

Technical Reviewer:
Monica Stevenson

PTR Editorial Services Coordinator:
Jen Blaney

Interior Layout Tech:
Bill Hartman

Cover Designer:
Mike Tanamachi

Indexer:
Larry Sweazy

Proofreader:
Tonya Cupp

For product information and technology assistance, contact us at **Cengage Learning Customer & Sales Support, 1-800-354-9706**

For permission to use material from this text or product, submit all requests online at **cengage.com/permissions** Further permissions questions can be e-mailed to **permissionrequest@cengage.com**.

All trademarks are the property of their respective owners.

Library of Congress Control Number: 2008931089

ISBN-13: 978-1-59863-799-1

ISBN-10: 1-59863-799-1

Course Technology
25 Thomson Place
Boston, MA 02210
USA

Cengage Learning is a leading provider of customized learning solutions with office locations around the globe, including Singapore, the United Kingdom, Australia, Mexico, Brazil, and Japan. Locate your local office at: **international.cengage.com/region**.

Cengage Learning products are represented in Canada by Nelson Education, Ltd.

For your lifelong learning solutions, visit **courseptr.com**.

Visit our corporate Web site at **cengage.com**.

Printed in the United States of America
1 2 3 4 5 6 7 11 10 09

This book is dedicated with love and appreciation

to my wife, Mishi, and son, Rajiv,

the best travel companions anyone could have.

Brooklyn, 18 Feb 2010

Happy birthday David,
hope this books gives you some ideas
for nice shots and that it also has
places in it you do not know yet.
Have fun and keep up taking pictures.
All the best

Acknowledgments

The book you're holding in your hands was made possible through the talent, advice, and assistance of a number of people. My sincere thanks go to Alan Gaynor and Christopher Lovi for their expert photo op recommendations and to Chester Higgins for valuable feedback during the image selection process. For research and logistical information, I'd like to thank Linda Corcoran of the Wildlife Conservation Society, Jeanne Fleming of the Village Halloween Parade, Danielle Officer of the Weeksville Heritage Center, and Chris Sams of the New York International Auto Show.

Special thanks must go to Kevin Harreld at Course Technology PTR for coming up with the concept for this series; my editor, Cathleen Small, for her keen eye while managing a tight deadline with skill and grace; Monica Stevenson, for ensuring the accuracy of the technical information; Bill Hartman for production layout; and Mike Tanamachi for the cover design.

About the Author

Amadou Diallo is a New York City–based photographer, author, and educator whose passion for travel photography has taken him around the world. His words and images have been featured in national magazines and have graced some of the most popular photography-related sites on the web. His fine art photography has been exhibited in galleries nationwide and is in a growing number of private collections. For information about his photography and workshops, please visit www.diallophotography.com. Amadou lives in Fort Greene, Brooklyn.

Contents

CHAPTER 3
Events ... 85

CHAPTER 4
Urban Oasis ... 123

Introduction

This book is one in a series of travel guides written for photographers. If your photographic ambitions begin and end with a cell phone camera, this book may offer little beyond pleasing images. But if photography plays a large role in your travel plans, this book is equal parts photo essay and how-to guide for capturing some amazing shots on your trip. Have you ever seen a published photograph and wondered just how it was created? Well, this is your chance to go behind the scenes as I walk you through all the steps necessary to re-create what's in the book. You'll come away with professional-quality images that will have friends and family marveling at your vacation photos.

Great Travel Photos

Taking a vacation snapshot is easy; just press the shutter button. Creating memorable photographs of your travels is another thing entirely. Thumb through any magazine of travel photos, and you'll find that the best contain three basic elements—a compelling subject, an interesting vantage point, and appealing light.

Pros may make it look easy, but the truth is that long before the camera comes out of the bag, a good deal of research and planning are required to combine these three factors in a single image. While on assignment, a travel photographer may spend days choosing subjects, exploring different vantage points, and waiting for the right weather before getting the shot that's finally published. For amateur shutterbugs in an unfamiliar city with only a limited amount of time to photograph, such in-depth preparation is rarely possible. The result? Disappointing photos.

This book helps you make the most of your photography in New York City by presenting 50 of the best photo opportunities the Big Apple has to offer. I'll show you exactly where to find the most interesting and least obstructed views, give you the best times of day to shoot, and guide you through the steps I used to photograph the images in these pages. Think of this book as your personal assistant. The research, location scouting, and planning have already been done, allowing you to dedicate your time to capturing stunning photographs of the city I call home.

New York City

New York City is one of the most popular tourist destinations in the world, combining an unrivaled cultural diversity with epicenters of culture, entertainment, and finance. For photographers, the city is truly an embarrassment of riches. With historical landmarks, vibrant street scenes, cultural delights, and world-famous icons spread throughout five boroughs, selecting only 50 photo opportunities to include in this book was a difficult task. I was guided by two main criteria: Does it make a compelling image? And, is photo access available to the general public? If I've left out any of your favorites, rest assured that many of mine didn't make the list either.

This book is a complement to, not a replacement for, a traditional guidebook. There are infinitely more places and events you should experience while in the Big Apple. Those featured in this book offer opportunities to capture the essence of what makes New York one of the world's greatest and most exciting urban destinations.

In a city as well documented as this one, pulling out a camera attracts little notice. As long as you are not blocking pedestrians or vehicles with your equipment, there is virtually nothing you cannot photograph while on public property. The few times you're likely to be asked anything about your photography will be based primarily on the equipment you're using. A tripod, a big lens, or a large camera bag signals that you're doing more than grabbing snapshots to email back home. But unless you are shooting for commercial or stock agencies, a simple explanation that the photographs are for your own personal use will usually suffice. Unless noted otherwise, none of the shots in this book require prior approval, permits, or fees.

Before and during your trip, there are three websites you'll find particularly helpful. The official New York City site is www.nyc.gov. Click on the Visitors link for up-to-date information about events, festivals, accommodations, and more. Navigating New York's subway system can be a daunting task for visitors. At www.hopstop.com, you simply type in a starting point and destination for detailed directions via mass transit. If you'd like to get a preview of your destination online, visit maps.google.com. The terrain map gives you a great overview of Manhattan's grid of streets and avenues. And for many addresses you can also view street-level photographs of the location.

How This Book Is Organized

Each chapter covers a particular theme, with photo opportunities arranged in alphabetical order. At the start of each photo opportunity, you will see weather icons followed by the best times of day to shoot. Taken together, this information helps you plan your daily itinerary based on optimal photographic conditions.

These icons indicate, from left to right, sunny, partly cloudy, overcast, and rainy conditions.

Accompanying text gives a brief overview of the history and significance of what's being photographed. Next, two shots for each photo opportunity are paired with detailed information showing you step-by-step how to get an identical shot. A photo caption provides lens and exposure information, as well as the time of day and the month the image was photographed. You'll also find travel directions and admission information.

Will My Photos Look Like Yours?

With this book you'll learn where to go, what to shoot, and how to photograph it for professional-looking results. But snapping the shutter is, in many ways, only the start to making a great picture. The skills involved in transferring high-quality images to your computer; making adjustments for contrast, color, and saturation; and then printing them are thoroughly covered in numerous books on digital photography. The focus of this book is on everything that happens up until the shutter button is pressed.

The appeal of a book like this is that you learn in great detail how to compose shots identical to those of a professional photographer. But please don't stop there. Everyone has his or her own way of seeing, and you may find that a different angle, time of day, or weather condition makes a more compelling statement about your personal experience in New York City.

I've identified 50 interesting subjects to photograph and shown you how I went about doing it. Whether you choose to duplicate every shot in the book or use these images to spark your own creative take on the city, my goal is for you to enjoy photographing this town as much as I do.

Photo Gear

The desire to capture professional-quality images doesn't mean you have to own the most expensive equipment. But you will need the flexibility that a single lens reflex (SLR) camera/lens system offers to duplicate the images between these covers. In many instances, a tripod will be required for a sharp image. I promise to keep the tech jargon to a minimum, but you should be familiar with terms such as aperture, shutter speed, depth of field, and focal length to get the most out of the sections describing how I set up each shot. These images were shot with a digital camera, but the concepts and techniques apply equally to film shooters.

Camera Bag

Whenever I show my images in seminars, workshops, or demonstrations, someone invariably asks, "What camera do you use?" I preface my answer by saying I'd rather view the

work of a great photographer with bad equipment than vice versa. It's photographers who make great pictures, not cameras. But since I'm sharing all my secrets with you, it's only fair that I let you look inside my camera bag, right? For this book, I shot with digital 35mm gear exclusively. The convenience, light weight, and variety of lenses available for this format make it an ideal choice for travel photography in cities. In the following images you can see my current setup.

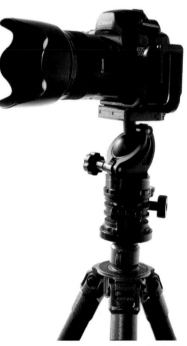

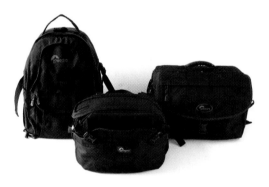

Among my camera bags are three models from Lowepro: the Mini Trekker backpack (left), Inverse 200 AW (center), and Nova 5 shoulder bag (right).

My equipment includes a Canon EOS 5D and a Gitzo 1227 MK II tripod. Mounted on the tripod are an Acratech Ultimate Ballhead and leveling base.

Equipment Rental

A great convenience of shooting in New York City is the wide availability of camera equipment for rent. If there's a particular shot detailed in this book that requires equipment you don't own, there are a number of rental houses that stock gear to fill almost any need. Two that I use often and recommend are Adorama (www.adoramarentals.com) and Calumet Photographic (www.calumetphoto.com/rental). Both stock cameras, lenses, tripods, and more. You can rent by the day or the week. These shops cater to working pros, so the equipment is kept in perfect working order.

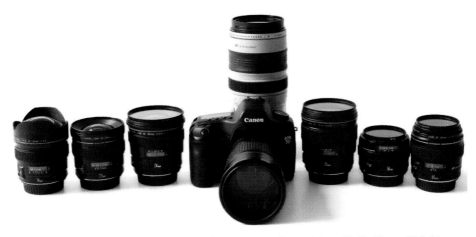

Images in this book were shot with, from left to right, the Canon 14mm f/2.8L, 20mm f/2.8, 24mm f/1.4L, 200mm f/2.8L (mounted on camera), 35mm f/1.4L, 50mm f/1.4, 85mm f/1.8, and 100-400mm f/4.5-5.6L IS (rear).

Digital Cameras and Focal Length

Unlike in the film days, when all SLR cameras used the same size of film, today's digital models vary in the size of the sensor that records the image. With an identical lens, two different cameras can provide different angles of view based solely on the physical dimensions of their sensors. On a full-frame sensor—one that measures 24×36mm—a 50mm lens is considered a standard view. But put that same lens on a camera with a smaller sensor, and a significant portion of the image is cropped off. To achieve a comparable view, you need to use a wider focal length. Table I.1 shows approximate focal length equivalents between a full-frame sensor and two reduced-size sensors. For simplicity's sake, all lens focal lengths listed in this book will correspond to their full-frame equivalents. If the dimensions of your camera's sensor are smaller than the 24×36mm film standard, you'll need to use a wider lens to achieve the same field of view.

TABLE I.1 APPROXIMATE FOCAL LENGTH EQUIVALENTS

To match the coverage of a full frame sensor at...	A 1.5x crop sensor needs a lens at...	A 2x crop sensor needs a lens at...
20mm	12mm	10mm
50mm	35mm	25mm
85mm	55mm	42mm
100mm	70mm	50mm
200mm	135mm	100mm

Okay, enough about gear. Let's get to the photos.

The Astor Place condominiums.

CHAPTER **1**
Architecture

New York is a city of ambition. You need no more evidence of this than to simply look up. The buildings, monuments, and grand structures remain an awe-inspiring testament to the city's transformation from a small Dutch trading outpost to one of the most famous cities in the world. Home to many of the nation's wealthiest capitalists, New York was a major player in the building arms race that began at the start of the twentieth century. From 1899 to 1973, the city was able to count the world's tallest building among its skyscrapers, a distinction reached by no less than eight separate buildings in Manhattan. In this chapter, we'll explore some of the architectural achievements that define New York City.

Shooting Like a Pro

The single greatest challenge to shooting architecture in this town is finding an unobstructed view of your subject. Whether it's neighboring buildings, trees, or parked cars, there's always something in the way. Further complicating matters, space is also tight; you can back up only so far. And more times than I care to recall, the perfect vantage point seems to be in the middle of a busy street. Professional photographers overcome these obstacles by selecting the right equipment and the most opportune times to shoot. You can do the same and create great photos that will have friends wondering just how you got that shot.

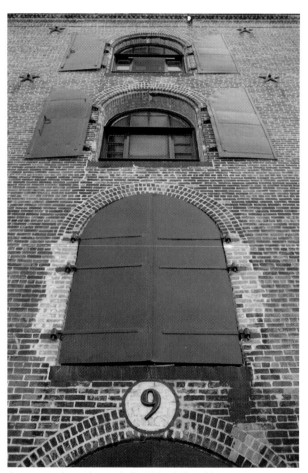

A converted warehouse in Red Hook, Brooklyn.

The Gear

Your most cherished tool when photographing architecture is going to be a wide angle lens. Using one allows you to stand close to a building and still capture it from top to bottom. Without this wide coverage, you're forced to point your camera up to include everything in the frame. This results in converging lines, with the building getting narrower as it rises. You can exaggerate this effect to make a bold statement, as seen in the Astor Place image that opens this chapter. But more often than not, you'll want to keep your vertical lines straight. A 20mm lens on a full-frame camera will suffice for most situations, though there are times when you may need to go as wide as 14mm. Wherever possible, use a tripod and bubble level to ensure that both horizontal and vertical axes are straight.

The Plan

New York is a 24-hour town to be sure, but things do slow down considerably in the early-morning hours. If sight lines to your subject are blocked by large crowds or heavy traffic, trying shooting at dawn. The city is magically calm, and the light is often at its finest, particularly for east-facing subjects. Of course, there are times when crowds are helpful for showing scale as well as adding a sense of the hustle and bustle of city life. And don't forget to include some detail shots. Seeing the entire structure top to bottom is great, but close-ups shot at interesting angles, such as in the image of a converted warehouse in Red Hook, or showing ornamental details, as seen in this picture of the Humanities and Social Sciences Library, give a more intimate perspective of the subject.

NOTE

Security concerns stemming from the attacks of September 11, 2001 have introduced restrictions on photographing buildings, particularly in Manhattan. Most commercial buildings no longer allow the use of tripods on their properties. Access to interiors has been severely curtailed in commercial buildings as well. Public institutions have a wide range of policies dictating interior photography, but tripods and flash are almost universally prohibited.

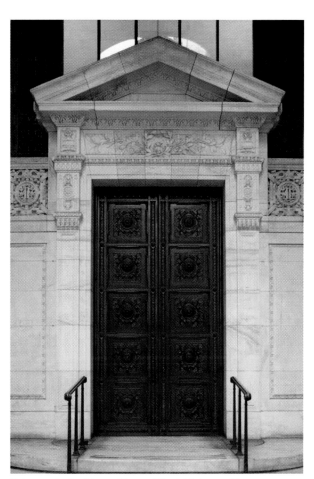

Entrance to the Humanities and Social Sciences Library.

 When to shoot: afternoon, night

Brooklyn Bridge

At the time of its completion in 1883, the Brooklyn Bridge was the world's longest suspension bridge, providing easy access between then-separate cities Manhattan and Brooklyn. Designed by John Roebling, this 13-year engineering feat came at a cost well beyond its $15 million price tag. Hazardous working conditions encountered while excavating the riverbed and laying the steel suspension cables claimed at least 20 laborers. Roebling himself died before construction even began, from an injury he sustained while surveying the site. His son, Washington Roebling, succeeded him as chief engineer, but extreme illness from his work on the riverbed soon forced him to delegate the daily responsibilities of the project to his wife, Emily.

To this day, the bridge has lost neither its charm nor its grandeur. Its distinctive Gothic arches and intricate steel cable arrangements can be experienced up close, day or night, with a walk across this engineering marvel. The wood-planked portion of the walkway is elevated above the vehicle lanes, offering unsurpassed views of the city's skyline. There are few strolls anywhere more pleasant than crossing the East River with blue skies and soaring gulls as your companions and a world-famous skyline awaiting your arrival.

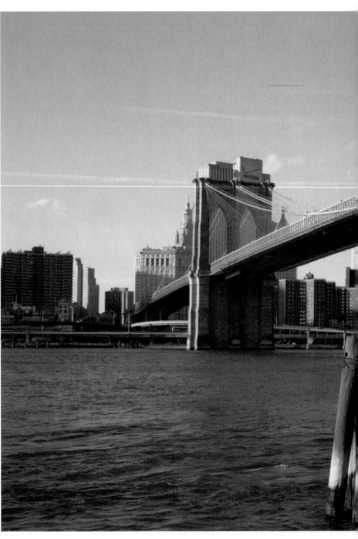

The Shot

To accentuate the span of this bridge, you need a low, angled vantage point close to the subject. The pier at Fulton Ferry Landing offers the perfect opportunity with an unobstructed view of the entire bridge. Shoot from a kneeling position right against the pier's railing to create a composition that feels as if you are actually on the water. Aim your camera at a 30-degree angle to the bridge to elongate the structure. By placing the leading line of the bridge in the upper-right corner of the frame, you lead viewers into the picture, taking them all the way to the Manhattan side of the span. With so much sky in the frame, this is a shot best attempted later in the day, as the sun is beginning its descent into the west. This ensures a rich blue sky and long, sculpting shadows, and it keeps the contrast of the scene within your camera's range. Including the weathered pilings in the foreground calls to mind New York's tradition as a port city. The gulls overhead are an added bonus and can be found year round.

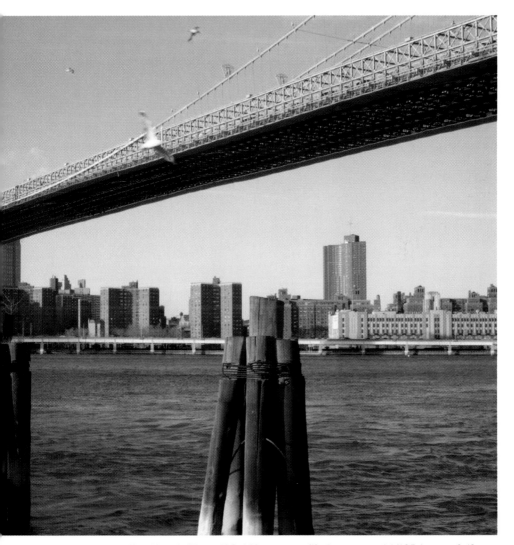

Focal length 35mm; ISO 100; aperture f/8; shutter speed 1/125; January 3:42 p.m.

The Shot

A dramatic nighttime view is found from the pedestrian walkway of the neighboring Manhattan Bridge. Set up 50 yards or so before reaching the first tower of this bridge (when entering from Brooklyn). You can frame both towers of the Brooklyn Bridge with lower Manhattan's skyline as an irresistible backdrop. The walkway is on the outer section of the Manhattan Bridge. For safety reasons, there is a metal railing topped by chain-link fencing at eye level. Within the railing, however, is a gap wide enough to accommodate most lenses. Set your tripod at waist height and wedge it against the railing to get an unobstructed view. The famed "necklace" lights framing the suspension cables are on from dusk until midnight. Nighttime shots involve long exposures and can be especially tricky to meter, so it's a good idea to bracket your shots. Try shooting at normal, +1, and −2 exposures. The best exposure is the one that captures the most shadow and highlight detail.

The colored lights you see in this image were part of a four-day celebration of the Brooklyn Bridge's 125th anniversary. On your visit the bridge will be just as spectacular, if somewhat less colorful.

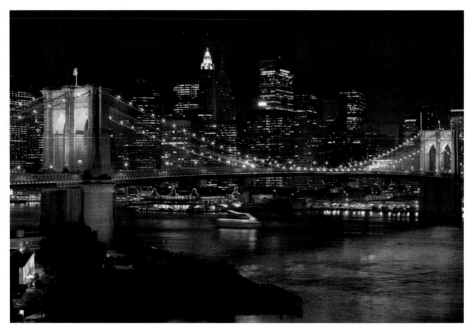

Focal length 50mm; ISO 200; aperture f/5.6; shutter speed 2.5 seconds; May 9:33 p.m.

Subway trains run regularly across the Manhattan Bridge on the same level as the walkway. You'll want to time your shots before and after trains come rumbling by to prevent the heavy vibrations from blurring the image.

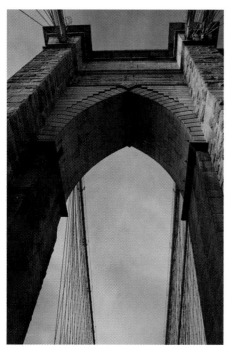

One of the Brooklyn Bridge's two granite towers.

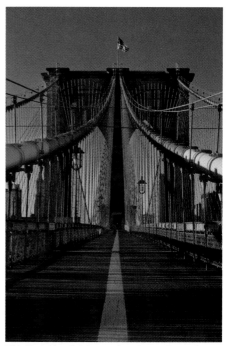

The Brooklyn Bridge pedestrian walkway.

Getting There

To reach the Fulton Ferry Landing, take the A train to the High Street station. Coming from Manhattan, ride in the last car; from Brooklyn, board the front of the train. Take the Fulton Street exit and walk downhill on Cadman Plaza West for three blocks to the river.

You can enter the Manhattan Bridge from either Brooklyn or Manhattan. Entering from Brooklyn: Take the A, C, or F train to the Jay Street station. Follow Jay Street walking away from the outdoor mall for about 15 minutes to Sands Street. Cross Jay Street and follow the fenced-in sidewalk to the staircase leading up to the pedestrian walkway. Entering from Manhattan: Take the B or D train to Grand Street. Walk one block west to Bowery Street. Turn on Bowery and walk two blocks south to Canal Street. Facing the bridge entrance, follow the signs for the pedestrian walkway on the south side of the bridge.

When to shoot: afternoon, evening

Chrysler Building

Arguably the most distinctive skyscraper in the city, the Chrysler Building is a treasured example of the Art Deco architectural style. Rising to more than 1,000 feet, it was completed in 1930 at the height of the skyscraper arms race. It was auto tycoon Walter Chrysler's aim to construct the world's tallest building. He indeed claimed the crown in dramatic fashion, but the title was short-lived. In less than a year, the Chrysler Building was surpassed in height by the Empire State Building. Chrysler conceived of his skyscraper as a testament to the modern machine age. The terraced crown is made of stainless steel and adorns a brick exterior. Exterior ornaments include replicas of hood ornaments and radiator caps from, you guessed it, Chrysler automobiles.

The Shot

A classic shot of the building's most distinctive element is relatively easy to photograph, if you've got the right lens. The southeast corner of 42nd Street and Sixth Avenue provides one of the least obstructed views of the building. Set up just behind the newsstand outside of Bryant Park with two of your tripod legs along the edge of the sidewalk. This position gives you an interesting angle from which to shoot and keeps you and your equipment out of pedestrians' way. Use a long telephoto lens to isolate the building's terraced crown from neighboring skyscrapers. Even from this distance, you'll have to point the camera up slightly. Just make sure that the building's windows appear level in your viewfinder. Shooting against a solid blue sky with the subject occupying the left part of the frame accentuates the bold Art Deco design.

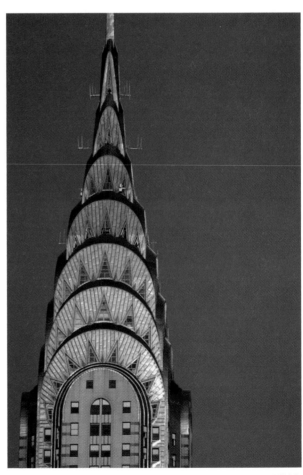

Focal length 400mm; ISO 200; aperture f/8; shutter speed 1/400; May 7:39 p.m.

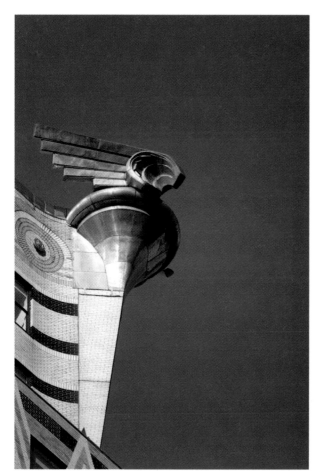

The Shot

A telephoto lens can be useful even when you are relatively close to your subject. Walking north on Lexington Avenue approaching 42nd Street, look up and you'll see this corner ornament on the Chrysler Building's 31st floor. It's a steel replica of a Chrysler radiator cap. Shoot with the ornament in the left side of the frame and include just enough of the building to show some of the contrasting brickwork. At this close range and steep angle, including too much of the building will make the skewed vertical and horizontal lines too prominent, drawing attention from your subject. As in the shot of the building's crown, a solid blue sky provides the stark backdrop needed to show off the Art Deco elements to best advantage.

Focal length 400mm; ISO 200; aperture f/5.6; shutter speed 1/800; May 5:29 p.m.

Getting There

The Chrysler Building is located at 405 Lexington Avenue at the corner of 42nd Street. Take the 4, 5, or 6 train to Grand Central Station.

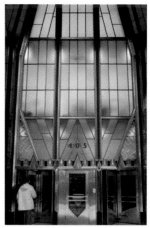

The Lexington Avenue entrance to the Chrysler Building.

 When to shoot: sunset, night

Empire State Building

No other icon conveys the romance and grandeur of New York City quite like the Empire State Building. Though its 40-year reign as the world's tallest building is long past, it is easily the most recognizable symbol of the city and still captures the imagination of tourists and residents alike. Its very history echoes the ambition and drive that define the Big Apple. Begun in 1930 during the Great Depression and completed less than 14 months later, its construction was part of a high-stakes race in New York City to claim the title of the world's tallest building. While the nearby Art Deco masterpiece, the Chrysler Building, was completed first, the Empire State relegated it to second place when it topped an incredible 1,250 feet upon its opening in 1931. At a cost of just over $40 million, the building was completed ahead of schedule and under budget. To get a sense of the far-reaching grandeur envisioned for this structure, the mast that sits atop the 102nd floor was originally intended as a mooring for passenger blimps that would dock via a rope and allow passengers to disembark on the building's observation deck. Understandably, this idea never came to fruition. But this soaring skyscraper remains today as much a symbol of New York as it ever has.

The Shot

Safe to say, there are very few publicly accessible places from which to shoot the top of the Empire State Building at eye level. The best is the Rockefeller Center observation deck, marketed as Top of the Rock. There are actually three floors of observation decks, and you'll want to continue all the way to the 70th floor. Unlike the lower decks, this floor is free of the tall glass partitions surrounding the perimeter. Sunset and twilight are far and away the best times to make photographs here. Just check the weather beforehand to ensure good visibility. In this shot, moments before the sun dipped below the horizon, its golden rays illuminated the structure's west-facing façade. Placing the building in the far left of the frame creates a sense of expanse in the crowded cityscape and gives a broader view of the Hudson River merging into New York Harbor at Manhattan's southern tip.

 The use of tripods and monopods is prohibited on the Rockefeller Center observation decks. But the stone parapets along the 70th floor observation deck offer a stable platform on which to support your camera.

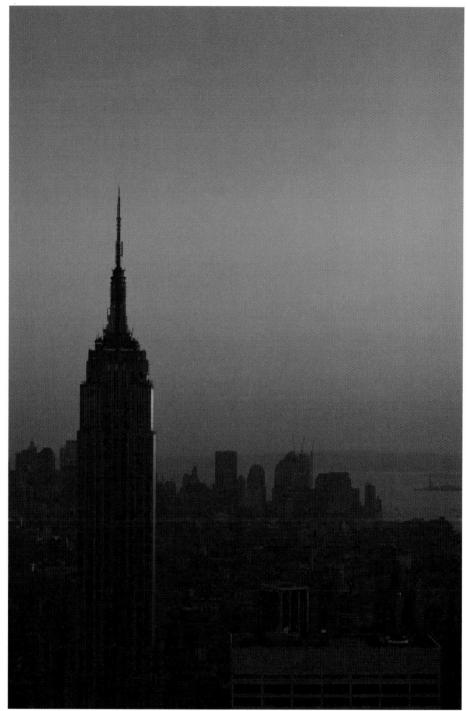

Focal length 85mm; ISO 400; aperture f/8; shutter speed 1/200; March 7:20 p.m.

The Shot

Shooting from a single vantage point doesn't mean all your photos have to look the same. From the same location as the previous shot of the building, turning the camera to a horizontal format and waiting for dusk creates a vastly different image. To center the Empire State Building in the frame and keep your camera perpendicular to it, you'll want to establish a position as far east as possible along the south façade of the observation deck. The trick to an effective nighttime photograph is to wait long enough for all the building lights to show, but shoot before the sky gets completely black and the contrast range becomes too great for your camera to record. If you have the option, shoot on a weeknight, because on weekends, many building lights are turned off to conserve energy.

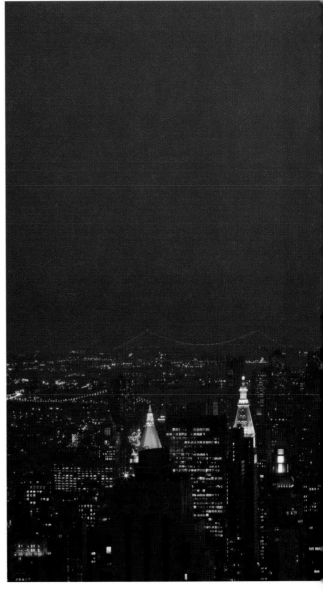

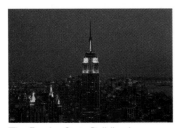

The Empire State Building in commemorative lighting.

 If you've got a few days in town, it's worth it to check the Empire State Building's lighting schedule at www.esbnyc.com. Colored lighting configurations like the one shown here are displayed throughout the year and can add a unique twist to a commonly photographed scene.

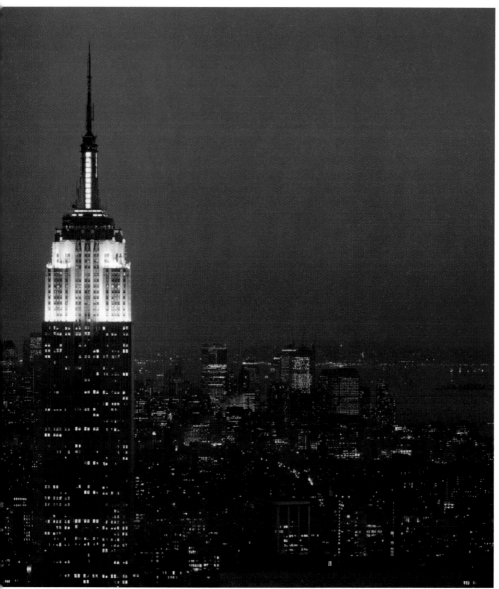

Focal length 85mm; ISO 400; aperture f/8; shutter speed 1/2; March 7:54 p.m.

Getting There

Take the B, D, F, or V train to the 47–50th Streets Rockefeller Center station. The ticket entrance is on 50th Street between Fifth and Sixth Avenues. Adult tickets are $20, and the observation deck is open from 8 a.m. to midnight seven days a week. You can avoid large crowds at sunset by visiting on a weekday.

 When to shoot: dawn, evening, night

Flatiron Building

It doesn't take much imagination to guess how the Flatiron Building got its name. It owes its distinctive shape to the triangular lot upon which it was constructed. At its narrowest point, the 22-story building is just over six feet wide. Its rounded corner sits at the convergence of Broadway and Fifth Avenue. The tapered design, while not the first of its kind, was certainly unique when the building opened in 1902. The anecdote goes that a popular wager among skeptical New Yorkers was how soon this fragile-looking gimmick would simply topple over. Not only has the building remained upright, it presides over a neighborhood now known simply as the Flatiron District. The limestone and terra cotta exterior is non–load bearing, but it serves to hide the steel frame that actually provides the building's structural support.

The Shot

The best place to photograph is from the small traffic island on Fifth Avenue between 22nd and 23rd Streets, just north of the building. The island is narrow, but there's just enough room to spread out the legs of your tripod. This location eliminates hanging tree branches and phone wires from the composition. Place the building's rounded corner in the center of your frame. This gives you a perfect vantage point as Broadway and Fifth Avenue recede into the distance on opposite sides of the building. Make the foreground more interesting by shooting at a slow shutter speed and waiting for traffic to pass by. Taxis come down this stretch often, and a blur of yellow adds motion and energy to the image.

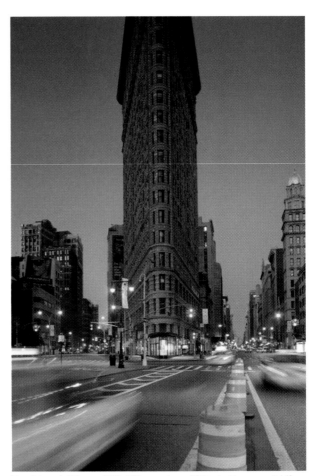

Focal length 20mm; ISO 400; aperture f/3.5; shutter speed 1/8; June 5:09 a.m.

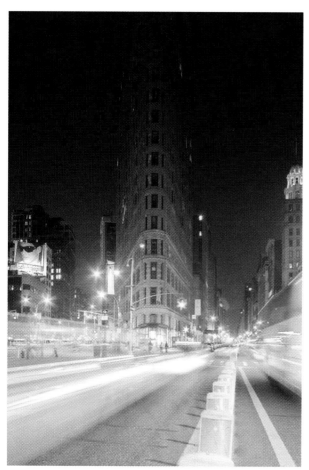

Focal length 20mm; ISO 400; aperture f/5.6; shutter speed 1.3 seconds; June 9:09 p.m.

The Shot

The time at which you photograph makes a big difference in the type of image you capture. From the same location as the previous shot of the Flatiron Building, try shooting at night for a much different feel. The long exposure time required to record the building allows the street and traffic lights to flare out into star shapes. Passing traffic is rendered as abstract swaths of color. The overall sense is one of tremendous energy, movement, and drama. Compare both images. Which one represents your vision of New York City?

Getting There

The Flatiron Building is located at 175 Fifth Avenue. Take the R or W train to the 23rd Street station.

When to shoot: afternoon, evening

Grand Central Terminal

By the turn of the century, New York City had become a major hub for continental train travel. But the soot, grime, and noise of the engines as they rumbled through midtown left a lot to be desired for citizens of the surrounding neighborhoods. In 1913, the heirs of Cornelius Vanderbilt opened a brand-new terminal that took advantage of the latest in technology—electrified train tracks. By doing away with steam and diesel engines, the trains could safely be routed to underground platforms. Apart from improving the quality of life for residents, this new underground terminal made it possible to lease the air rights above it for development. In short order, the area around Grand Central Terminal experienced a construction boom and became a highly sought-after location. An extensive series of renovations in the mid-'90s has brought back the grandeur of the terminal's original design. The city's Landmarks Preservation Commission has awarded landmark status to both the interior and exterior of the terminal.

The Shot

This famous sculpture depicting Mercury flanked by Hercules and Minerva can be shot from the northwest corner of Park Avenue and 41st Street. Use a telephoto lens to compress the perceived distance between the sculpture and the building behind it, making the latter appear as a patterned backdrop. A long lens also limits the field of vision, hiding the vertical skewing that results from pointing the camera up. Position your camera so that the words Grand Central Terminal are centered in the frame.

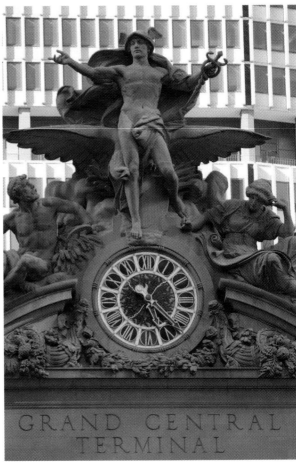

Focal length 200mm; ISO 800; aperture f/5; shutter speed 1/400; May 5:25 p.m.

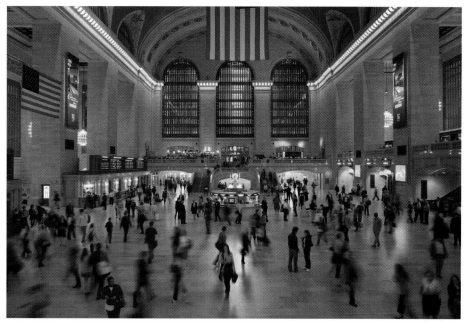

Focal length 24mm; ISO 400; aperture f/4.5; shutter speed 1/4; April 7:34 p.m.

The Shot

This view of the Main Concourse is the most popular and easiest shot to get of the terminal. Walk up to the balcony of the east-side staircase and set up your tripod so that the middle window is in the center of your frame. Shoot during rush hour, when the terminal is bustling with commuters. Use a slower shutter speed to put everyone in motion, creating a more dynamic image. Including people is an effective way to emphasize the grand scale of the terminal's architecture. Photography is allowed in all public areas of the terminal. But in order to use a tripod, you must contact the stationmaster's office ahead of time and request a pass.

 An interior scene with sunlight coming through large windows can easily exceed your camera's contrast range. One solution is to shoot in the evening when the outside light is weakest.

Getting There

Take the 4, 5, or 6 train to the 42nd Street Grand Central Station. The terminal is open from 5:30 a.m. to 1:30 a.m. For permission to use a tripod, call the Metro North Press Department at (212) 672-1200.

When to shoot: afternoon, sunset

IAC Building

IAC is the digital media conglomerate headed by media mogul Barry Diller. With a sprawling collection of e-commerce and other web-based entities under its roof, it's no surprise that when it came time to design a corporate headquarters, IAC was thinking big. They tapped none other than world-renowned architect Frank Gehry to design what, surprisingly, is his first building in New York City. Completed in 2007, the design is meant to evoke the windswept sails of a yacht—a nod to the building's location just off the Hudson River. Its most striking feature is the radically curved all-glass exterior, allowing the building's very character to shift seemingly hour to hour. During the day, clouds and sky are reflected in its 35×22 foot panels. As night falls, the interior lighting adds a luminescence to the structure that makes it feel as though it is floating above the street. A marvelous ship indeed.

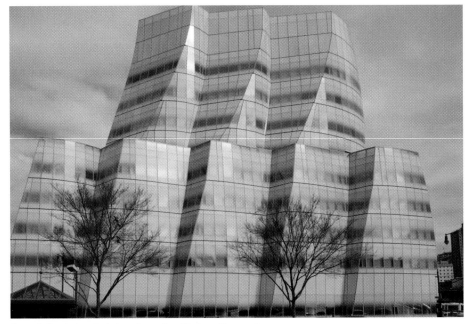

A partially obstructed view from the Chelsea Piers entrance.

The Shot

A relatively easy shot to get, this composition is handheld and taken from the sidewalk of the IAC Building's western facade. Point your camera straight up to exaggerate the sensual curves of the building. The glass exterior is like a giant mirror, so shoot in the afternoon on a day with puffy but fast-moving clouds for an ever-changing tableau. This shot contrasts the clouds and sky directly above the building with those reflected west of it. You can easily capture a variety of shapes and patterns by experimenting with different camera angles and positions. The image here is just one of many possibilities.

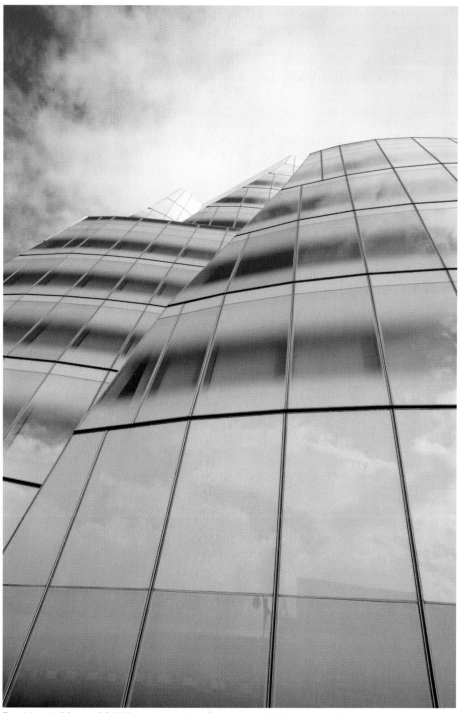

Focal length 20mm; ISO 200; aperture f/8; shutter speed 1/800; March 3:49 p.m.

The Shot

To photograph this building head on, you'll need the widest lens available for your camera. The challenge here is the presence of the six-lane West Side Highway. The most ideal vantage point would put you in the middle of traffic! Head for the bike path in front of the Chelsea Piers sports complex and set up your tripod on the landscaped partition with the building centered in your viewfinder. This is the best location for an unobstructed view. Back up any further, and the trees along the highway median will obscure part of the building, as seen on the previous page. It's likely that you'll need to tilt your camera up slightly to include the top of the building when shooting in landscape orientation. As the building itself contains few straight lines, the resulting distortion is not objectionable (except perhaps to the architect). For this west-facing façade, you'll want to shoot just

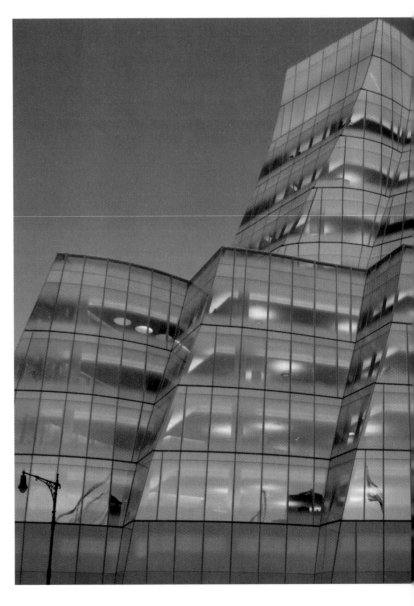

before sunset. The sky will turn a nice, rich blue, and the building's interior lights will balance nicely with the remaining daylight. Because the sun is setting behind you, casting shadows onto the glass exterior, you won't have much time between the absence of shadows and full darkness. So be ready!

Getting There

The IAC Building is located at 555 West 18th Street. Take the A, C, E, or L train to the 14th Street/Eighth Avenue station. Walk two blocks west to Tenth Avenue. Make a right on Tenth Avenue and walk north to 18th Street. Make a left on 18th Street and walk to the bike path at Chelsea Piers, crossing the West Side Highway.

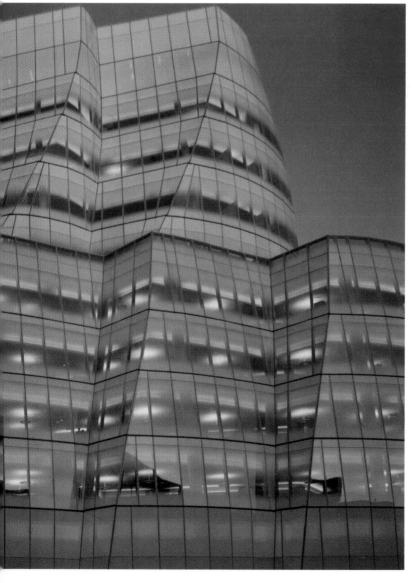

Focal length 14mm; ISO 100; aperture f/8; shutter speed 1/13; March 7:06 p.m.

 When to shoot: dawn, evening

Lever House

Arriving at this corner of Park Avenue, it's hard to imagine the area free of commercial buildings. But at its completion in 1952, this pioneering example of modernist design was the first office tower in what had been an exclusively residential neighborhood. Built for the soap manufacturer Lever Brothers and shunning the masonry style of contemporary sky-scrapers, the Lever House combined an all-glass exterior with innovative geometry. The building is composed of a vertical slab that appears to float atop a horizontal base suspended above ground by columns along its perimeter. The base is hollow in the center, revealing a public plaza and a sculpture garden showcasing artwork from the Lever House collection. The openness of the design—the narrow tower utilizes only a fraction of the site's zoned square footage—reflects an era when public space was regarded as an integral part of corporate architecture. In the late '90s, a complete restoration of the building revived the weathered façade and added the sculpture garden, which was omitted during construction. At only 24 stories, the Lever House may not rise above many of its neighbors, but its impact on commercial architecture is undisputed.

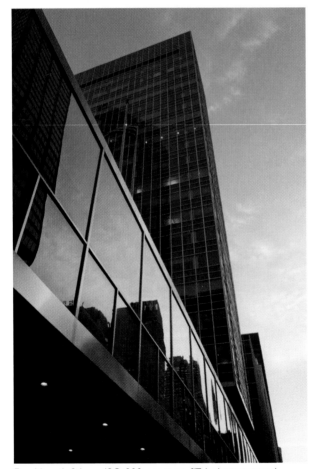

Focal length 24mm; ISO 800; aperture f/7.1; shutter speed 1/125; April 6:17 a.m.

The Shot

A great shot that emphasizes the building's bold geometry can be taken at the northwest corner of 53rd Street and Park Avenue. With a wide-angle lens, stand just outside the building's horizontal base and point your camera straight up to include the top of the structure. The leading lines of the horizontal base take viewers' eyes right to the vertical slab. With so much sky in the composition, the weather and time of day become crucial. Both clear skies and patchy clouds work fine. This shot is best attempted at dawn before the sky gets too bright. Otherwise it will be difficult to render both highlight and shadow detail in the same exposure.

The Shot

To capture a full view of the building, simply cross Park Avenue and shoot from the enormous plaza of the Seagram Building. Due to security restrictions, you cannot set up a tripod, but the plaza is wide and deep enough that you can capture the street and top of the building with a focal length of 24mm. The Seagram Building's plaza contains a large fountain that adds a nice horizontal balance to the dominant vertical slab of the Lever House, echoing its horizontal base. The upper floors of the eastern façade reflect the sky and clouds, so it's a good idea to shoot either early or late in the day when the sun is closer to the horizon.

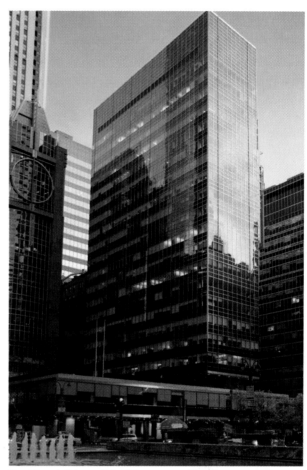

Focal length 24mm; ISO 800; aperture f/2.8; shutter speed 1/160; April 6:13 a.m.

Getting There

The Lever House is located at 390 Park Avenue. Take the E or V train to the Lexington Ave/53rd Street station. Walk one block west on 53rd Street to Park Avenue.

The Lever House sculpture garden.

 When to shoot: dawn

The Plaza

Memorialized as the residence of the children's book character, Eloise, The Plaza hotel has long been a benchmark of luxury accommodations and is arguably the most famous hotel in the city. Built in 1907, with 1,000,000 square feet spread over 21 stories, the hotel has catered to world leaders and movie stars. Its chateau-style exterior leaves no doubt as to the Old World extravagance that is lavished upon its guests. And then there's the location. It sits at the intersection of tony Fifth Avenue and the southern entrance to Central Park. So what sort of amenities can you expect in a building where rooms can run more than $1,000 a night? Crystal chandeliers, 24-karat-gold faucets, and full-time butler service, for starters. The Plaza has recently reopened after a two-year, $400 million renovation and is now composed of a combination of residential and hotel units, offering the chance for the well-heeled to claim one of the more prestigious addresses in the city. The building itself is designated as a National Historic Landmark, and its upper floors feature stunning views of Central Park.

The Shot

For a head-on shot of the hotel, cross Fifth Avenue and set up on the plaza in front of the Apple Store. A tripod is a must, as you'll never keep the lines in the building straight without one. You'll face two main obstacles to getting a clear line of sight: parked cars and food vendor stalls. It's not uncommon to find a backhoe or a service van blocking a full view of the hotel. You only have one real option for eliminating such obstructions: Shoot early morning, preferably on a weekend. Traffic will be light, so you'll have ample periods of a car-free Fifth Avenue. And if you ask nicely, most food vendors, who are just setting up their stalls for the day, are happy to temporarily slide them out of view.

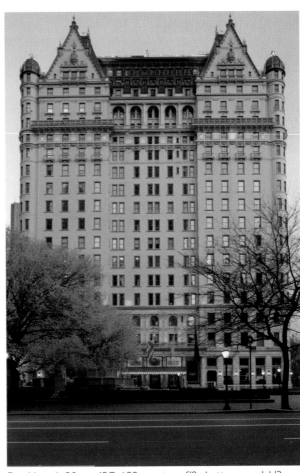

Focal length 20mm; ISO 100; aperture f/8; shutter speed 1/3; April 6:18 a.m.

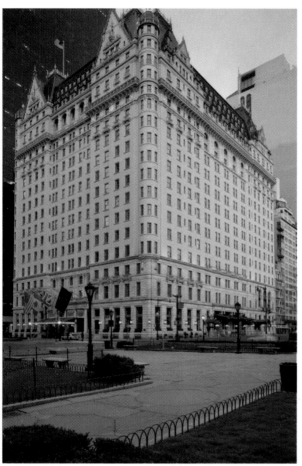

Focal length 20mm; ISO 100; aperture f/8; shutter speed 1/6;
April 6:23 a.m.

The Shot

A very popular vantage point that takes in both the north and east sides of the hotel can be found in the northern half of Grand Army Plaza. Use a wide-angle lens and place the building's rounded corner in the center of the frame. Again, a tripod and bubble level are key for maintaining straight lines. By including the greenery in the foreground, you can better place the building into context as a neighbor of Central Park. During the day the plaza gets quite crowded with tourists, street performers, and nearby workers enjoying a break, so early morning makes a great time to shoot.

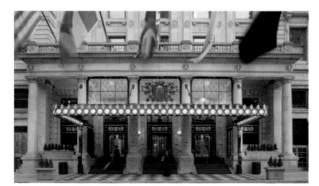

The Plaza Hotel entrance.

Getting There

Take the N, R, or W subway to the Fifth Ave/59th Street station. Walk one block south on 5th Avenue to 59th Street.

 When to shoot: dawn, afternoon, sunset, night

Skyline

One of the most identifiable features of any city is its skyline. And New York is no exception. If you're fortunate enough to fly into New York with a view of Manhattan, the island appears to be a giant Erector set of skyscrapers. The city as we know it was developed south to north, beginning in lower Manhattan and advancing along Broadway. With the city's financial center concentrated at the island's southern tip, it's no wonder that the lower Manhattan skyline in particular is full of imposing buildings. Luckily, there is no shortage of locations from which to get amazing shots.

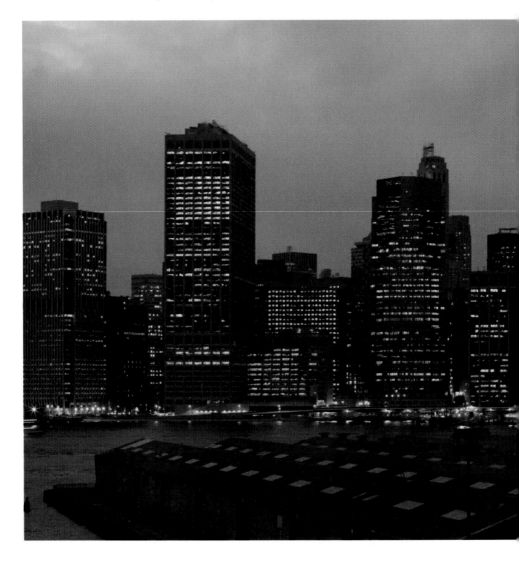

The Shot

One of the best vantage points of Manhattan's skyline can be found in Brooklyn. The Brooklyn Heights promenade offers a dramatic nighttime view across the East River. Set up your tripod anywhere between the row of benches and the guardrail. It's nearly impossible to find a bad vantage point. There is a large expanse of the river in the foreground, so include the low-lying Brooklyn shipyard to add interest to the scene.

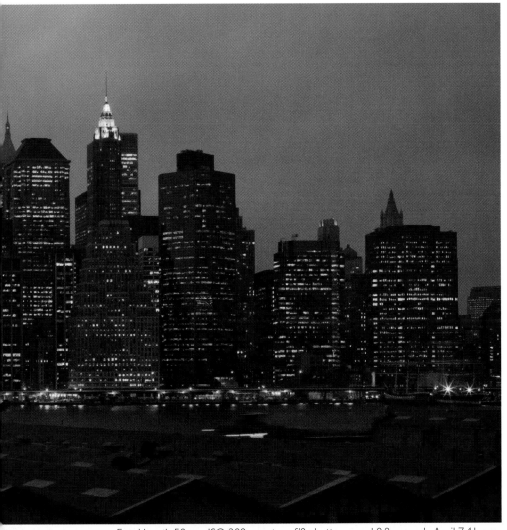

Focal length 50mm; ISO 200; aperture f/8; shutter speed 0.8 seconds; April 7:41 p.m.

The Shot

An equally impressive view of the skyline can be found on the water. The Circle Line's Harbor Lights cruise departs from the West Side piers and takes you on a two-hour tour of the island. Less than a half hour into the cruise, you will come past Manhattan's southern tip. As the ship begins its way up the eastern side of Manhattan, the Staten Island Ferry terminal comes into view. Place the terminal in the center of the frame, and you capture the curve of the island. A wide-angle lens allows you to include significant areas of both the sky and water. Set a fast shutter speed so you come away with sharp images even with the rocking motion of the boat.

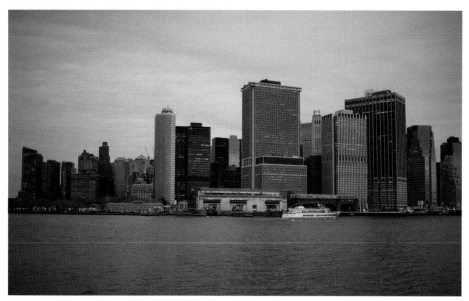

Focal length 35mm; ISO 800; aperture f/1.4; shutter speed 1/500; April 7:42 p.m.

Getting There

To reach the Fulton Ferry Landing, take the A train to the High Street station. Coming from Manhattan, ride in the last car; from Brooklyn, board the front of the train. Take the Fulton Street exit and walk downhill on Cadman Plaza West for three blocks to the river.

The Circle Line cruises depart from Pier 83. Take the 1, 2, 3, 7, 9, A, C, E, N, Q, or R train to the Times Square 42nd Street station. Walk west on 42nd Street to Twelfth Avenue. For tickets and schedule information, visit www.circleline42.com.

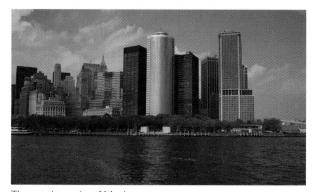

The southern tip of Manhattan.

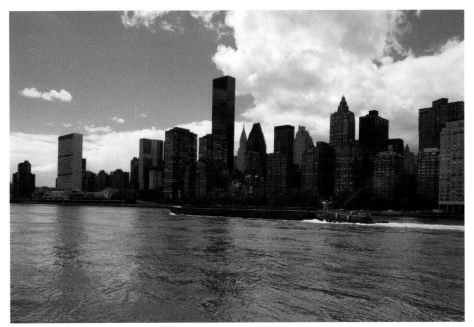

Midtown Manhattan viewed from Roosevelt Island.

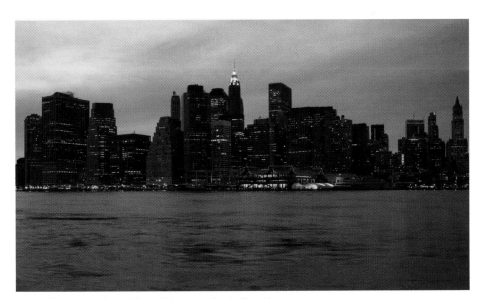

Lower Manhattan viewed from Fulton Landing in Brooklyn.

Statue of Liberty

You'd be hard-pressed to find a more recognizable symbol of the U.S. than the Statue of Liberty. It was a gift from France to commemorate the alliance against the British in the American Revolution. Packed and shipped in more than 300 separate pieces, the statue was officially unveiled in 1868. As one of the first, and certainly most impressive, sights to greet new arrivals, the statue has long been associated with the immigration entry point of Ellis Island. At 151 feet tall and weighing more than 200 tons, the statue's exterior is actually made of copper. Just like a penny that has been left out in too much rain, the brutal conditions of sitting in an exposed bay have turned the statue green over the decades. Although that sounds like something that should be cleaned up, the oxidation has formed a protective coating, preventing damage to the underlying metal.

The Shot

If your primary interest in the Statue of Liberty is photographing it, save yourself the long-lines to visit Liberty Island. Tourist ships sail numerous times during the day and pass right by the statue. WIth a 400mm lens you can try a horizontal composition to create an intimate portrait of Lady Liberty. The boat will approach with the statue on the right. Place the statue in one side of the frame and let the sky and clouds fill the remaining space. Shoot at a very fast shutter speed to eliminate camera shake caused by a heavy lens or a rocking boat. This situation calls for a lens that incorporates some form of image stabilization technology. With this you can retain sharp images at slightly slower shutter speeds.

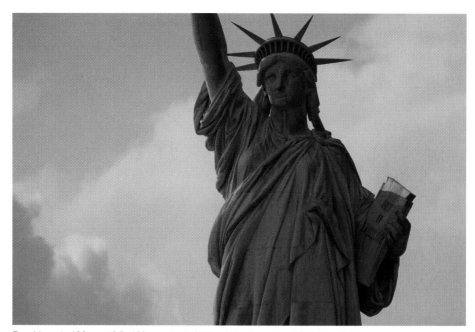

Focal length 400mm; ISO 400; aperture f/13; shutter speed 1/1000; May 5:14 p.m.

The Shot

Once the tour boat passes directly in front of Liberty Island, a 200mm lens allows you to show adequate detail of the statue and its pedestal when shooting in a vertical format. Here are a couple of things to consider that will ensure you get the best possible photo op. When boarding your ship, make sure to sit on the top deck and, if possible, sit in the rear of the boat. As the statue approaches, everyone will stand up to take their own photos, so try to position yourself against the railing for a view that does not include the backs of people's heads.

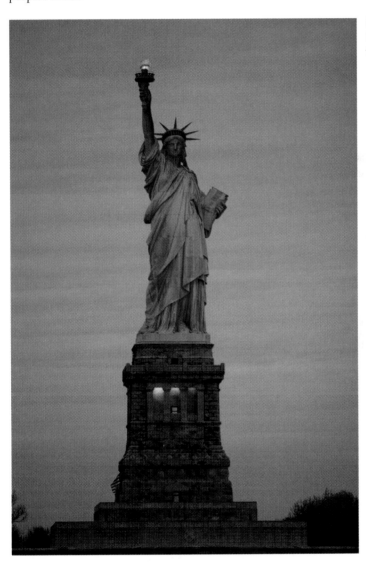

Focal length 200mm; ISO 800; aperture f/2.8; shutter speed 1/500; April 7:33 p.m.

Getting There

The Circle Line cruises depart from Pier 83. Take the 1, 2, 3, 7, 9, A, C, E, N, Q, or R train to the Times Square 42nd Street station. Walk west on 42nd Street to Twelfth Avenue. For tickets and schedule information, visit www.circleline42.com.

When to shoot: dawn, sunset

Supreme Courthouse

The New York State Supreme Courthouse overlooks Foley Square just a few blocks north of City Hall. Unlike other states, New York has a supreme court in each of its 62 counties. This one represents Manhattan. In 1913, a competition was held to select a design for the building, which would replace the (still-standing) Tweed Courthouse as the home of the New York County justices. Famed architect Guy Lowell of Boston was chosen as the winner of the commission. It's worth noting, though, that his original design, calling for a circular building, was eventually rejected, and he was forced to revise his plans into the more traditional-looking neoclassical-style building you see today. The courthouse officially opened for business in 1927 and has been an official city landmark since 1966. After you've gotten your photo op, make sure to take a walk alongside the courthouse on Worth Street. You'll find that Lowell's revised design is actually a hexagon, providing one of the building's most unique characteristics.

The Shot

This shot is a prime example of how purposefully creating converging lines in a photograph can create a compelling image. There are any number of creative possibilities when such strong architectural detail is at your disposal. I encourage you to find other angles and perspectives that work equally as well. Here's how to duplicate this shot. From the top of the staircase, start at the far left of the courthouse and walk down about 14 steps. Frame the composition so that the third column from the left is in the center of your viewfinder. Tilt the camera up until just a small portion of sky is visible at the top of the frame. There are two keys to making this shot a winner. Use a wide-angle lens. The extended field of view exaggerates the converging lines, making for a powerful image. Use a tripod. While you are tilting the camera up for effect, you still want a level horizon so that the building "feels" straight. You can accomplish this by using a bubble level mounted in your camera's hotshoe, or simply use the foreground steps as a visual aid in maintaining a level horizon.

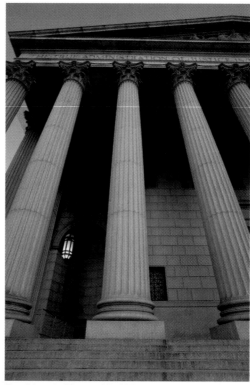

Focal length 20mm; ISO 200; aperture f/8; shutter speed 1/3; October 6:30 p.m.

The Shot

Photographing the courthouse from a head-on perspective could not be easier. Walk directly across Centre Street. There's a red emergency call box on the sidewalk, and positioning your tripod just to the right of it should place the courthouse entrance right in the center of your viewfinder. Even with a 20mm lens, you will not be able to include the building's top triangular pediment if the camera is to remain level. But that actually works to your advantage. In the shot you see here, eliminating the top of the building from the composition accentuates the vertical columns and gives added prominence to the George Washington quote engraved across the façade. For the most professional-looking photo, shoot when the sun is near the horizon so that the luminance of the sky is only a couple of stops brighter than the building. This allows you to capture sufficient detail throughout most of the building against a pleasing blue sky.

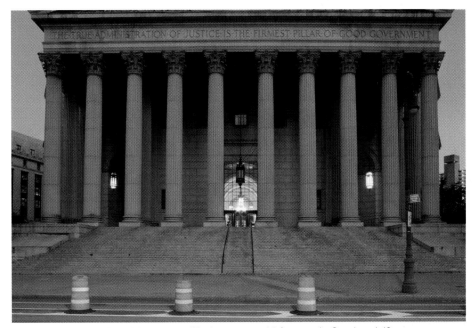

Focal length 20mm; ISO 200; aperture f/8; shutter speed 1.3 seconds; October 6:42 p.m.

Getting There

The courthouse is located at 60 Centre Street between Duane and Worth Streets. Take the 4, 5, or 6 train to the Brooklyn Bridge/City Hall Station. Walk north on Park Row with the Brooklyn Bridge on your right. At Reade Street, bear to the right as Park Row merges into Centre Street.

The courthouse and surrounding square hum with activity during business hours. The best time to photograph is on the weekend. By the evening, when most tourists have passed through, you'll have the courthouse to yourself, with ample opportunity to try varied compositions without getting in anyone's way.

 When to shoot: dawn, afternoon

Woolworth Building

Commissioned by five-and-dime king Frank Woolworth, this famed "cathedral of commerce" opened in 1913 as the world's tallest building. Woolworth derived a staggering fortune from his eponymous chain of discount stores—where items did actually sell for five and ten cents. Seeking a company headquarters in Manhattan for which no expense would be spared, Woolworth settled on an ornate Gothic revival style as an everlasting testament to his business success. The original construction budget of $5 million quickly grew, as Woolworth lavished both the interior and exterior with detailed embellishments and even extended the building's height beyond the original proposal. Perhaps most impressive, though, is that he was able to pay for all of this in cash, to the final tune of $13.5 million. The building's terra cotta skin hides a steel frame construction and is adorned top to bottom with ornamental details.

The Shot

A relatively easy shot to get, this composition is handheld. The building's immense height makes it impossible to shoot anything but the entrance and lower floors from the surrounding neighborhood. Fortunately, the Brooklyn Bridge offers both the necessary height and the distance to capture the majestic upper floors of this building. From Manhattan, walk across the bridge until you reach the point where the steel cables begin to rise, heading for the east tower (the second one). This location provides the least obstructed view and gives you just enough of an angle to catch afternoon side-lighting along the building's southern façade. A day with patchy clouds adds an interesting backdrop.

 While the Brooklyn Bridge offers the perfect vantage point, the wood-planked section of the walkway transfers every bit of vibration from the car traffic on the lower level. A tripod is useless in these conditions. Instead, set a high ISO and open your lens to a wide aperture so you can handhold your telephoto lens at a fast shutter speed.

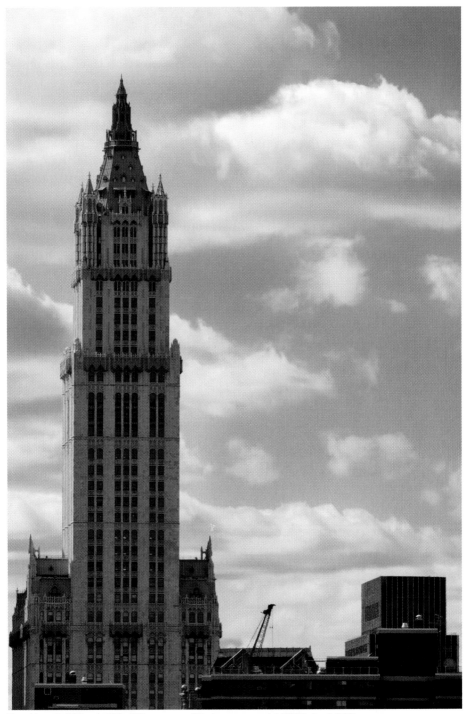

Focal length 200mm; ISO 400; aperture f/8; shutter speed 1/2000; April 3:55 p.m.

The Shot

Public access to the ornate lobby has been prohibited since the September 11, 2001 attacks. But you can still capture some of the building's grandeur by photographing the arched entrance. Set up directly across Broadway and use a wide-angle lens to capture the full height of the arches. Including pedestrians is a great way to showcase the enormous scales of the arches. Here, I've used a slow shutter speed to slightly blur the motion of the pedestrians, giving a sense of the hustle and bustle of the city. A tripod is a must for

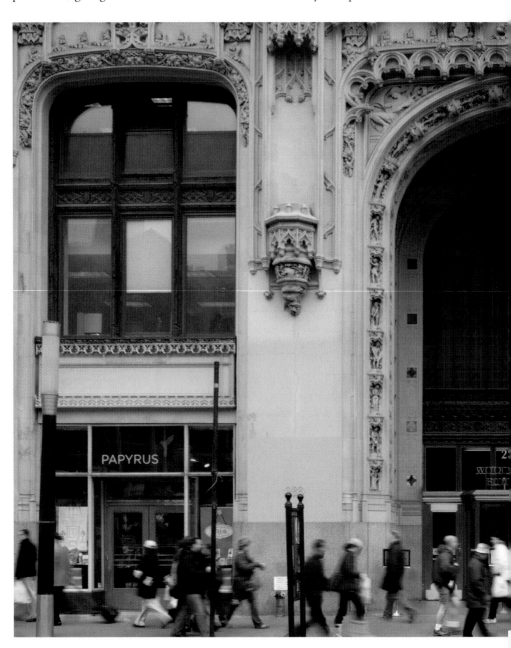

achieving this effect. Overcast days provide even light across the building, with no harsh shadows.

Getting There

The Woolworth Building is located at 233 Broadway. Take the 2 or 3 train to the Park Place station. Exit at the intersection of Park Place and Broadway. The Woolworth building is directly across Park Place.

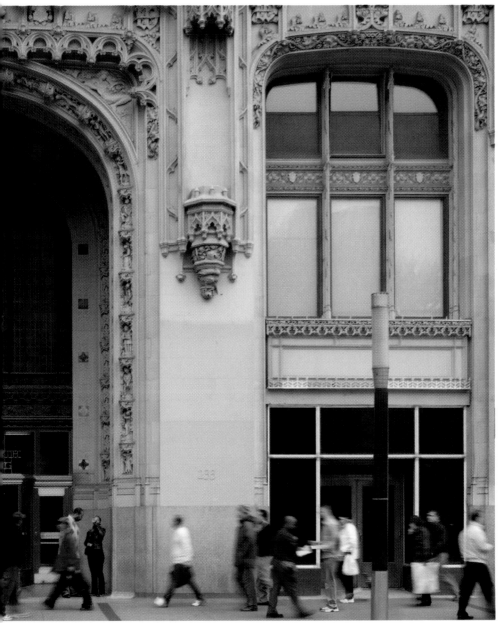

Focal length 24mm; ISO 100; aperture f/13; shutter speed 1/13; April 1:15 p.m.

Meditating in Union Square Park.

CHAPTER 2
City Life

I f the true measure of a city lies in its people, New York City delivers in spades. Home to more than 8 million residents, this melting pot of ethnicities, lifestyles, and demographics is the most densely populated city in the country. The city's ethos of inclusion and opportunity continues to attract new arrivals. Some are drawn here to follow their dreams; others come to simply make a better life for their families. This unique mix of viewpoints, cultures, and talents provides the buzz and energy for which this town is famous. During your visit, you're bound to experience at least a few of the 200 languages spoken here. In this chapter, we'll explore the mosaic of city life that makes New York City such a rewarding experience for both visitors and residents. From urban hipster hangouts to ethnic enclaves, this chapter is your guide to people watching as we visit the places where New Yorkers live, work, and play.

Shooting Like a Pro

Spend any time at all showing your vacation pictures, and you'll quickly find that people are most captivated by photographs of other people. A professional photographer on a travel assignment will make it a point to include images of people interacting with their surroundings. For most amateur shutterbugs, however, the idea of walking up to a complete stranger and asking to take his picture ranks right up there with getting a wisdom tooth pulled. Some forgo it altogether, missing the opportunity to share the full experience of their visit. Others resort to furtively snapping away from across the street with a tele-photo lens. But they give up the sense of intimacy and trust between subject and camera that makes compelling portraits. The good news is that coming away with great people shots is not as difficult as you may imagine. With a little bit of practice and know-how, you can capture shots that showcase daily life in the Big Apple.

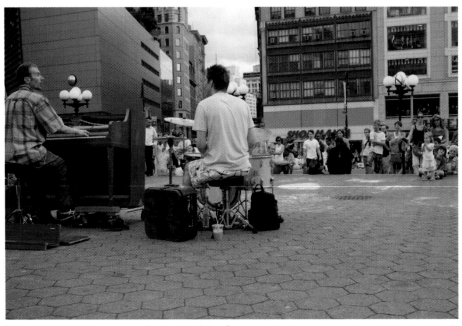

Piano player and drummer performing in Union Square.

The Gear

For travel photography portraiture, I'm a big fan of wide-angle lenses. In fact, most of the images in this chapter were shot with a 35mm lens. Using this focal length *forces* you to get close to your subject. I've found that closer physical proximity actually puts people more at ease. It's akin to having a friendly conversation versus shouting across the room. The wider-than-normal coverage of a 35mm lens also lets you include context, a crucial element in travel photography. Is your subject in a park, on the street, or in front of a famous icon? You want to give viewers a sense of place. As an example, look at the image of the two musicians in Union Square. I was just a few feet behind them. If I had used a 50 or 85mm lens, the pianist and drummer would have filled the frame. But the wider angle of a 35mm lens let me include the crowd that gathered for the performance, as well as the buildings across 14th Street. The city is full of amazing backdrops. Take full advantage of them.

Father and daughter enjoying a view of the Hudson River.

The Plan

Venturing out to photograph strangers can be a bit daunting. Regardless of how awkward you may feel doing it, the reality is that most people are flattered when someone wants to take their picture. So it really just comes down to having the confidence to ask. Here are some tricks of the trade that can increase your chances of getting a yes.

❋ **Dress for success.** I'm not advocating that you wear a suit and tie, but neither would I show up in cutoffs and a beer-stained T-shirt. People make judgments based on how you present yourself and may be less trusting of someone who looks like he just rolled out of bed.

❋ **A good mood is contagious.** So is a bad one. Honesty, a smile, and a pleasant demeanor go a long way toward capturing a great portrait. The end of a long, frustrating day when your patience is worn thin is not the best time to go shooting street portraits. You want to approach people in a friendly, positive mood.

❋ **Be decisive.** When you see someone you'd like to shoot, don't hover nervously like a stalker while working up the courage to ask the person's permission. Approach him right away. Have an icebreaker ready. If it's his clothes that attracted you in the first place, give a compliment on the outfit and then ask whether you can take his picture. Both the Mohawk-sporting kid with pierced eyebrows and the fashion plate working the lime green suit are undoubtedly used to the attention.

❋ **Sweeten the pot.** Offer to send your subject an 8×10 print or a digital file as a thank you. Make sure you follow through on your promise, though, or you'll ruin it for the next photographer the person meets.

❋ **Always ask.** Unless you're shooting a crowd scene, tell the person you'd like to take his picture. Aside from being a common courtesy, this can often turn into a conversation starter, putting both you and the subject more at ease. For a brief discussion of whether you also need to obtain written consent, see the sidebar, "A Model Release Primer."

❋ **Don't take rejection personally.** If someone says no, just move on to another opportunity. Remember, the only way to get comfortable asking for permission is to practice. Set yourself a modest goal, such as, "Today I'll ask three people if I can take a photograph." In no time, you'll find that it's easier than you thought.

 Make sure your exposure, focal length, ISO, and other settings are dialed in *before* you ask to take someone's picture. No one likes standing around waiting while you fiddle endlessly with knobs and dials on the camera.

A MODEL RELEASE PRIMER

A model release is an agreement, signed by the person being photographed, that grants you the right to use his or her likeness. Whether or not you need to obtain one is determined by your intended use of the image. For specific guidance you must consult a legal professional. But the following information can provide you with at least a basic understanding of the issues.

In short, anyone can take a photograph of a person in a public space. If the images are destined for your own personal use and enjoyment, a model release is not necessary. But if you plan to license, sell, or otherwise exploit the likeness of a specific individual for commercial use, or to endorse an idea or opinion, you'll need to have a signed release on file.

Shooting images for stock and advertising agencies are two obvious examples for which releases are required. And indeed, no reputable agency will offer to license your work without signed model releases. But these are far from the only scenarios under which a release may be required.

Suppose, in addition to your day job, you have a weekend business taking family portraits. On vacation you capture an amazing portrait that you want to feature on the home page of your website to attract new clients. You'll need a release to do so. Why? You've appropriated someone's likeness as an endorsement of your business. Whether the image actually leads to any sales is immaterial.

Again, the rights of an amateur and professional photographer to take someone's picture remain equal. The presence or absence of a model release simply governs how the image can be used. If you're wondering how photojournalists manage to get releases while shooting chaotic or dangerous events, the answer is they don't. Images used for editorial coverage, such as newspaper and magazine articles, are considered fair use and do not require a release. Works of artistic expression typically fall under the same category, meaning that exhibiting your photographs in a gallery does not require a release, regardless of the selling price.

Should you determine that you do require a model release, a quick Google search will turn up dozens of sample releases that you can modify for your own use. Keep a supply in your camera bag and ask potential subjects to sign the release before you photograph them.

 When to shoot: afternoon, evening

Brighton Beach

In New York City, the desire to immerse yourself in another culture requires nothing more than a subway ride. This becomes evident the moment you set foot in Brooklyn's Brighton Beach neighborhood. Known affectionately as Little Russia by the Sea, Russian émigrés have been arriving here since World War II. But the major transformation came in the '70s, when a relaxation of Soviet immigration policies led to an influx of Ukrainians. Thus the neighborhood you see today—markets and storefronts with Russian-language signs, nightclubs with Vegas-style entertainment, and newsstands carrying the latest titles from back home. Oh, and the ocean is just a couple of blocks away, with great views along the boardwalk. In Brighton Beach you step into a New York quite apart from the typical tourist experience.

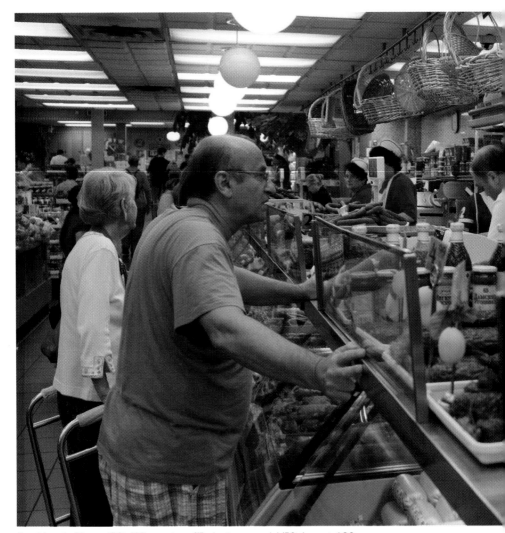

Focal length 35mm; ISO 400; aperture f/5; shutter speed 1/50; August 4:20 p.m.

The Shot

Food plays an important role in many cultures. The Brighton Beach community is no exception. For an authentic food experience, M&I International Food at 249 Brighton Beach Avenue is hard to beat. This popular market imports specialty goods and also serves up its own fare to satisfy a clientele that craves food from back home. A great place to set up for a shot is at the end of the deli counter with its seemingly endless selection of meat. This is a very busy shop, so it won't take long for the counter to fill with customers. Try to catch the moments like this one, when the clerk and customer are engaged in conversation, looking directly at each other. Keep the viewer's attention in the center of the frame by making sure you have sharp focus on your subjects.

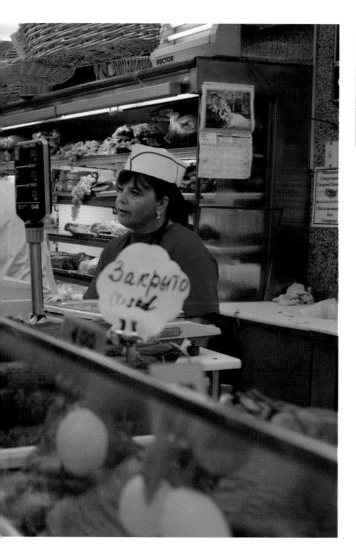

NOTE

Always ask permission before taking photographs in a place of business or other private location.

The Shot

Good photography, more often than not, is simply about waiting for the right moment. A case in point is this meat market at 1049 Brighton Beach Avenue. The Russian script, bold graphics, and huge photo of meats simply beg to be photographed. Stand on the edge of the sidewalk, place focus on the shop's awning, and then wait for something interesting to happen. After a few moments, this traffic cop came into view. Once she passed under the awning I fired a quick series of shots. In this one she is perfectly centered under the awning, her legs in mid-stride. The uniformed traffic cop (a New York icon) who is African-American, walking past a Russian butcher shop, makes a compelling statement about the diversity of daily life in the city.

Focal length 35mm; ISO 400; aperture f/5.6; shutter speed 1/640; August 4:00 p.m.

Getting There

Brighton Beach extends from Corbin Place to Ocean Parkway and is bordered by Neptune Avenue and the Atlantic Ocean. Take the B or Q train to the Brighton Beach station and walk along Brighton Beach Avenue in either direction.

Subway platform.

Brighton Beach Avenue.

Shopping for produce on Brighton Beach Avenue.

When to shoot: afternoon, evening

Bryant Park

Situated in the heart of midtown, Bryant Park's fastidiously maintained expanse of green is a popular outdoor destination for New Yorkers. Twice a year the park is host to Fashion Week, the most influential fashion show in the United States, featuring the world's top designers and supermodels. The rest of the year the park is fully open and accessible to the public. With generous seating provided throughout its 9 acres, the park is a perfect lunch spot and after-work meeting place. During the winter months a public ice rink is installed. The most stunning aspect of Bryant Park is best appreciated while relaxing on its central lawn. The tree-lined park appears as an oasis carved out of the mass of skyscrapers surrounding it on all sides. Enjoy the grandeur of the city's architecture with the comfort of grass between your toes.

The Shot

On Monday nights from June through August, HBO, whose offices are directly across 42nd Street, sponsors an outdoor film series in Bryant Park. The park fills up quickly, with people arriving straight from work to ensure a good spot. Walking along the perimeter of the lawn offers a number of compelling scenes to photograph. To duplicate this shot, walk to the south end of the lawn and face north. Shoot from a low vantage point so that the crowd fills the bottom half of the frame. The tree-lined promenade between the park and office towers provides a perfect backdrop, showing the park in its midtown environment.

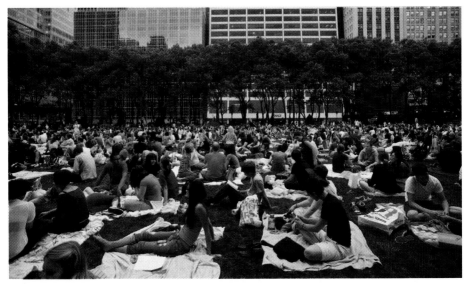

Focal length 20mm; ISO 400; aperture f/5; shutter speed 1/100; July 7:56 p.m.

The Shot

The park is a popular lunchtime spot for nearby workers. From spring through fall, an afternoon stroll on any weekday with nice weather will offer numerous opportunities for photographs like this one. The promenade on the north side of the park is lined with trees on either side of lush groundcover. In this shot the table and chairs are perfectly arranged in the center of the promenade, offering a well-balanced composition. I approached this group of young women and asked if I could photograph them while they carried on with their lunchtime conversation. I used a very wide aperture to blur the background while keeping these women into sharp focus. Fire off a number of shots to ensure you get at least one with everyone's eyes open and no unflattering facial expressions.

Focal length 35mm; ISO 100; aperture f/2.2; shutter speed 1/500; August 2:22 p.m.

Children's carousel at Bryant Park.

 Want more exciting images? First seek out a captivating background. Then simply wait for something interesting to happen in front of it.

Bryant Park sits behind the main branch of the New York Public Library.

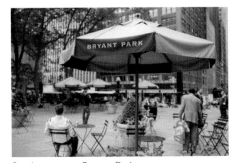

Seating area at Bryant Park.

Getting There

Bryant Park stretches from 40th to 42nd Street between Fifth and Sixth Avenues. Take the B, D, F, or V train to the 42nd Street/Bryant Park station.

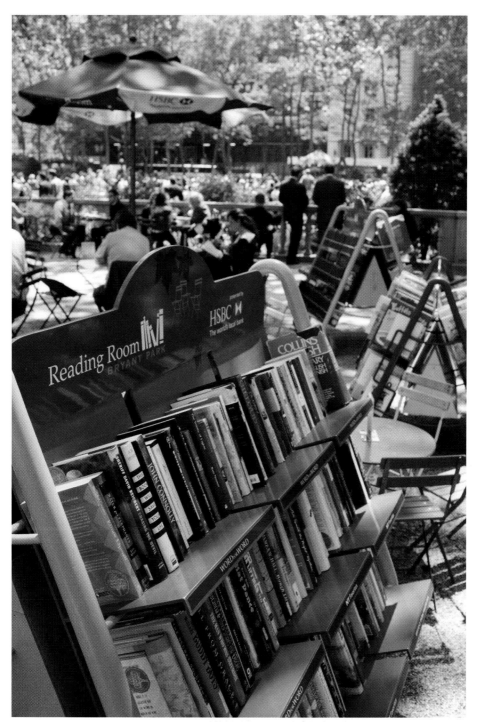

Bryant Park's free outdoor library.

When to shoot: afternoon, evening

Chinatown

Chinatown is a vibrant, thriving community that dates back to the late 1800s. With political and racial tensions on the rise, large numbers of Chinese laborers fled the Western U.S. and settled in New York City. The lack of integration opportunities for these immigrants led to an insular and self-supported society that thrived on an underground economy largely invisible to outsiders. Social mores and customs survived intact from generation to generation. To this day, Chinatown remains a popular destination for newly arrived immigrants. You'll find shops, restaurants, and markets that reflect both modern and traditional aspects of Chinese culture. Whether you seek Asian pop CDs or medicinal herbs, a trip through Chinatown's always-crowded streets will never disappoint.

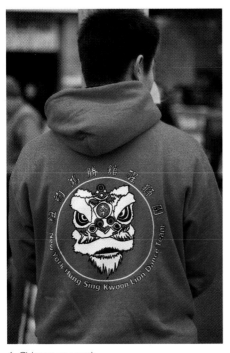

A Chinatown youth.

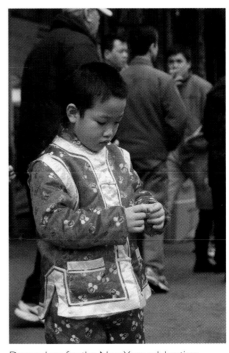

Dressed up for the New Year celebration.

The Shot

The dragon is an important symbol in Chinese culture. And there's no easier time to find one than during the annual Chinese New Year parade. Arrive an hour before the parade starts and enter the staging area on Mott Street north of Canal Street. This puts you directly onto the parade route, where you can follow the action from start to finish alongside news and freelance photographers. No one is checking credentials, so just act like you belong and try not to get too jealous over everyone else's gear. Since you're free to move about, shoot nice and tight for compositions that fill the frame with color and blur background elements.

Focal length 135mm; ISO 100; aperture f/8; shutter speed 1/500; February 12:36 p.m.

The Shot

Chinatown is famous for its crowded sidewalks and bustling markets. But if you're a tea lover—and you want a less clichéd photo op—head to the Ten Ren Tea and Ginseng Co. at 75 Mott Street. For $40 you can arrange for a 20-minute private tasting session where you'll sample some exquisite (and very expensive) loose teas, learn about the history of tea-making, and watch the proper techniques for a perfectly prepared cup. The teapots, utensils, and cups all make for fascinating objects to photograph. If you explain your wishes ahead of time, you're free to take as many photos as you like, both during and after the tea

Focal length 50mm; ISO 800; aperture f/3.2; shutter speed 1/30; February 1:49 p.m.

ceremony. To get this shot, my tea hostess graciously arranged the items on the tray. I set a wide aperture to restrict focus to the middle of the frame.

Getting There

Chinatown extends from Broadway to Essex Street between Worth and Grand Streets. Take the J, M, N, Q, R, W, Z, or 6 train to the Canal Street station. The Chinese New Year is based on the lunar calendar. For exact parade dates for the coming year, visit www.explorechinatown.com.

When to shoot: afternoon, evening

Coney Island

As far back as the 19th century, New Yorkers looking to escape the summer heat have flocked to Coney Island. Barreling down the Cyclone, enjoying the view atop the Wonder Wheel, and eating a Nathan's Famous hot dog are longstanding traditions that still exist for your enjoyment. In its heyday, Coney Island drew millions from all walks of life to enjoy surf, sand, and debauchery. While today's crowds may be smaller, the true spirit of Coney Island can still be found in everything from sideshow performances to evening strolls along the boardwalk. Plans have long been underway to take the area upscale. The New York Mets even built a stadium for their Class A minor league baseball team. And the famous Fourth of July hot dog eating contest is now carried live by ESPN. But much of the area retains the nostalgic, if decaying, charm of the days when Coney Island was "the playground of the world."

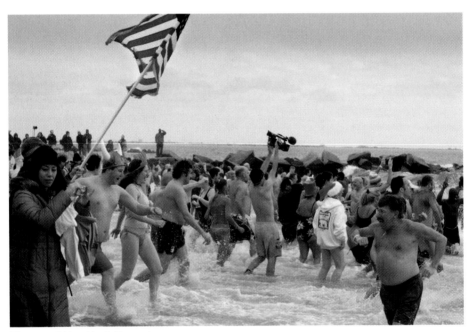

The annual New Year's Day swim.

The Shot

One of the best things about photographing a parade is the guaranteed willingness of people to pose. In the staging area of the annual Mermaid Parade (see the sidebar "Mermaids in Brooklyn"), this sea-themed Betty Boop was a joy to photograph. Working her props to the hilt, she kept the sun off her face with the umbrella and added an extra dash of color with her lollipop. I used a wide aperture to blur the rather uninteresting background. By shooting from my knees with the camera pointing up I was able to make her fill the frame from top to bottom.

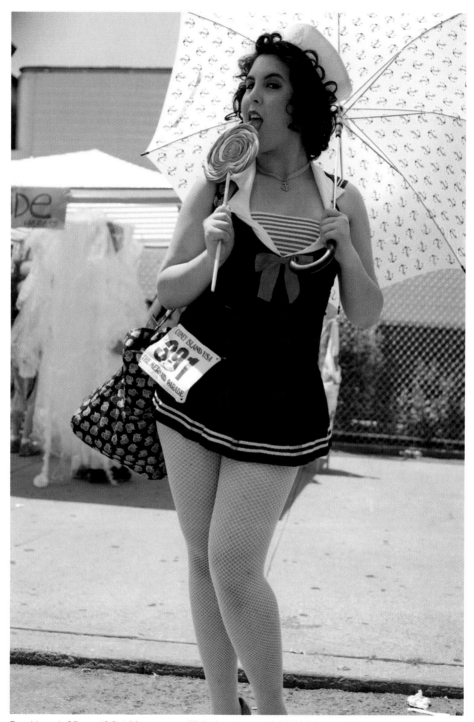

Focal length 35mm; ISO 100; aperture f/3.5; shutter speed 1/1000; June 1:44 p.m.

MERMAIDS IN BROOKLYN

If you're in town in late June, you don't want to miss the annual Mermaid Parade at Coney Island. Begun in 1983, the parade has grown into an established New York tradition without losing one ounce of its irreverent spirit. Billed as the largest art parade in the country, the event draws thousands of participants who arrive with elaborate costumes, floats, and choreography to usher in the summer season, Coney Island–style. You'll see a bit of everything here, from topless mermaids to giant sea creatures. To handle the crush of photographers who descend on the event each year, the parade organizers sell $5 passes to the staging area. Once inside, you can take as many photographs as you like of the participants as they wait for the parade to get underway. Believe me, there are no shrinking violets in this crowd. You're guaranteed to come away with great shots of some of the most outrageous costumes you'll ever see. The parade usually takes place on the Saturday closest to the official start of summer. For exact dates and other parade information, visit www.coneyisland.com.

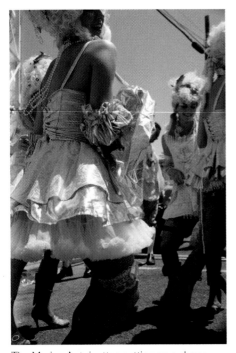

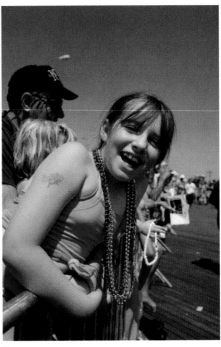

The Marine Antoinettes putting on a show. Spectator along the parade route.

If you're shooting portraits on a sunny day, move your subject into some shade. You'll get a soft, even light and avoid unflattering shadows under the eyes.

The Shot

The Wonder Wheel should be the centerpiece of at least one shot you take at Coney Island. The ride dates back to 1920, stands 150 feet high, and can hold as many as 144 passengers. To get this shot, enter Deno's Wonder Wheel amusement park from the boardwalk entrance. Just inside the gate, you'll be staring right at the Wonder Wheel. I crouched down low in order to place the Wonder Wheel at the very top of the frame. With the flagpole on the right and the Wonder Wheel in the center of the frame, I waited for an interesting mix of passersby. The couple on the right had just entered the frame and is taking in the scene in front of them. The Pakistani man at left in traditional dress adds some of the city's ethnic diversity. Shooting a half hour before sunset yields a pleasing sky with the orange glow of the sun illuminating the clouds close to the horizon.

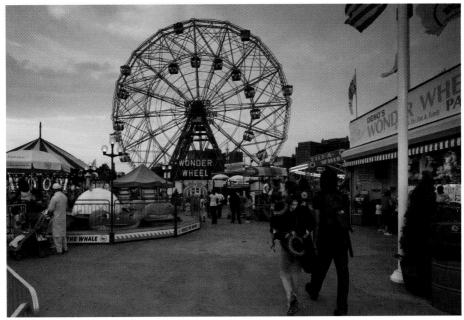

Focal length 20mm; ISO 400; aperture f/6.3; shutter speed 1/125; August 7:43 p.m.

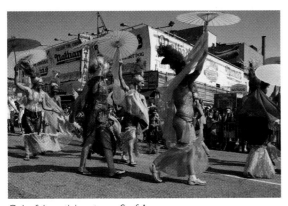

Colorful participants on Surf Avenue.

Getting There

The amusement rides are open seven days a week from Memorial Day through Labor Day. Take the D, F, N, or Q train to the Coney Island/Stillwell Avenue station. Cross Surf Avenue and head to the boardwalk.

 When to shoot: afternoon

Flea Markets

When you're ready to put your haggling skills to the ultimate test, head out to one of the city's weekend flea markets. The *cool* quotient of flea markets has soared in recent years. These markets are popular with the style-conscious crowd seeking to satisfy their inner home-makeover host. The vendors that make up the flea market circuit run the gamut. From the old-timer hawking vintage license plates to boutiques offering the latest fashions, there are a wide variety of items on display. Whether you're looking to buy or you just like to bathe in the wake of urban hipster cool, the flea market scene puts you shoulder to shoulder with New York's savviest bargain hunters.

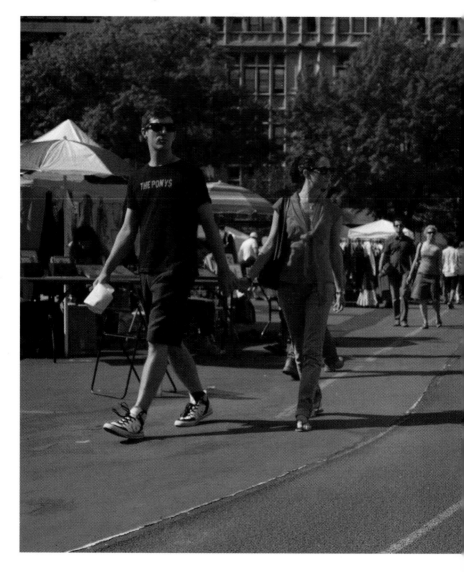

The Shot

The Brooklyn Flea, operating in the athletic field of a Catholic high school, is the newest entry on the flea market scene. It's also quickly become one of the most popular. Photo opportunities abound. In this shot I placed the colorful garments on the right and crouched down on my knees to emphasize the curve of the running track. Shooting low to the ground gives viewers the sense that they are in the picture as opposed to simply observing the scene. I waited for this couple to approach the edge of the frame, giving them prominence without obscuring the scene behind them. Notice the splash of green provided by the background trees.

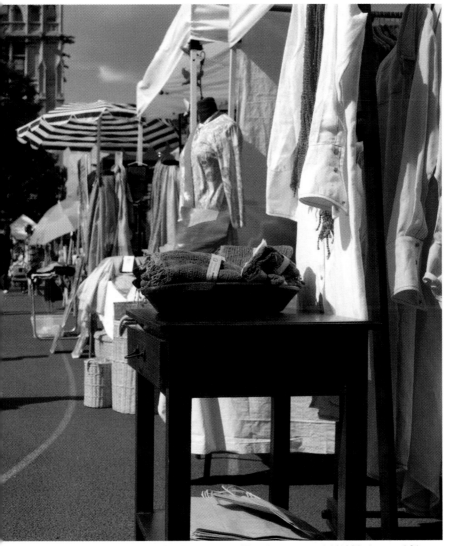

Focal length 35mm; ISO 100; aperture f/5.6; shutter speed 1/1000; August 4:01 p.m.

The Shot

Flea markets are a wonderful opportunity for people-watching. In this shot, again at the Brooklyn Flea, I simply chose a location and waited for an interesting collection of people to wander by. The symmetry of two absorbed shoppers on the right with two men engaged in conversation on the left was enhanced by the woman in the striped top making her way in between them.

Focal length 35mm; ISO 100; aperture f/5.6; shutter speed 1/500; August 3:59 p.m.

Getting There

The Hell's Kitchen flea market is on 39th Street between Ninth and Tenth Avenues. Take the A, C, or E train to the 42nd Street/Port Authority station. Walk south to 39th Street and one block west to Ninth Avenue.

The Garage flea market is at 112 West 25th Street between Sixth and Seventh Avenues in, appropriately enough, a parking garage. Take the 1 or 2 train to the 23rd Street station. Walk north to 25th Street and turn right.

The West 25th Street flea market is located between Fifth and Sixth Avenues. Take the N, R, or W train to the 23rd Street station. Walk north to 25th Street and turn left.

The Brooklyn Flea is on Lafayette Avenue between Clermont and Vanderbilt Avenue. Take the G train to the Clinton-Washington Avenues station in Brooklyn. Walk two blocks south on Lafayette Avenue.

A porcelain Marilyn Monroe at the Hell's Kitchen flea market.

Items at the Garage flea market.

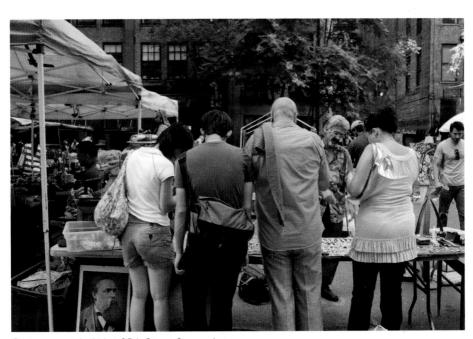

Customers at the West 25th Street flea market.

 When to shoot: afternoon, evening, night

Greenwich Village

In the '50s, Greenwich Village was a magnet for those seeking the latest in jazz innovation (bebop), youth culture (the Beat movement), and the bohemian lifestyle of forward-thinking intellectuals and artists. By the early '70s, the area had also planted the seeds of the gay and lesbian rights movement. In today's Greenwich Village, the ethos of anti-establishment bravura has yielded to spiraling real estate values. You're more likely to pass a Ralph Lauren boutique than a gathering of poets. But that doesn't mean that the Village, as it's known by locals, has nothing left to offer. You'll find the obligatory adult stores and tattoo parlors clustered along Sixth Avenue and West 4th Street. But this neighborhood rewards time spent meandering along its numerous side streets. An abundance of Colonial-era houses, celebrity-worthy restaurants, and opportunities to observe the locals awaits.

The Shot

Village Cigars is a neighborhood icon that dates back to 1938. It is also sits on one of the best people-watching corners in the city. Located at the intersection of Christopher Street and Seventh Avenue South, there is foot traffic here at all hours. From club kids in search of the next party to Wall Street bankers returning home from the office, New York doesn't get any more authentic than this. Set up your tripod on the edge of the sidewalk, placing the entrance to the shop in the middle of the frame. Shooting at night means a long exposure, which has the added benefit of blurring, rather than freezing people in motion. This makes for a more dynamic image. Another key compositional element in this shot is that pedestrians are present in the left, right, and center of the frame.

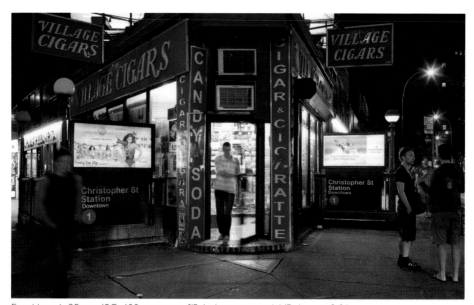

Focal length 35mm; ISO 400; aperture f/5.6; shutter speed 1/5; August 9:01 p.m.

 Shooting at night makes it difficult to avoid blowing out highlights in streetlights and other illuminated objects while showing detail in shadow areas. One solution is to capture two separate exposures—one adjusted for the highlights, the other for the shadows. Then use image-editing software such as Adobe Photoshop to combine the appropriate elements of each exposure.

Clothing boutique on Bleeker Street.

Basketball at "The Cage" on West 4th Street.

NOTE

The most famous landmark in the Village is undoubtedly Washington Square Park, with its majestic arch. At the time of this writing, the park is in the midst of a substantial renovation. The park is scheduled to reopen in the spring of 2009 and should be at the top of your list of places to visit and photograph.

The Shot

Outdoor seating is a staple of Greenwich Village eateries. This small French bistro on the corner of Bleeker and Grove provides a great photo op with its Mediterranean blue façade and large glass windows. Parked cars are your nemesis when trying to photograph street-level views of restaurants. Luckily, there is a fire hydrant on the sidewalk directly across from where the two women are sitting. As an added bonus, a designated bike lane runs right past the restaurant, giving you the option of standing in the street without getting hit by a car! Take more shots than you think you'll need. Passersby will inevitably walk into

your shot. Beware of unflattering expressions on the faces of the patrons. You don't want an otherwise perfect image to be ruined because someone has a glass to his face or is putting food in his mouth.

Getting There

Greenwich Village is bounded by 14th Street to the north and West Houston Street to the south, and extends from Broadway all the way to the Hudson River. To reach Village Cigars, take the 1 train to the Christopher Street station.

Focal length 24mm; ISO 400; aperture f/3.2; shutter speed 1/80; August 7:29 p.m.

When to shoot: morning, afternoon, evening

Music Under New York

Live music in the subways is a time-honored tradition for both musicians and listeners. But it's never actually been legal to play and solicit donations. In 1985, the transit authority decided to make this practice legit. Each year since, they've held auditions and authorized the selected musicians to perform in designated stations throughout the subway system. Dubbed Music Under New York, the program has attracted a variety of musicians performing classical, jazz, blues, and traditional music from around the world. Make no mistake; most of the performers are professional musicians who have spent years dedicated to their craft. No *American Idol* rejects here; it's New York, after all.

The Shot

When I came across this group of musicians, a large crowd had already gathered in front of them to listen. Instead of blocking everyone's view and shooting the band head on,

I moved to the side next to the drummer. Between songs I asked his permission to photograph. When photographing to convey energy and emotion, closer is often better. So I chose a 35mm lens. This let me shoot just a couple of feet away from the drummer and still include everything of interest in the frame. Lighting is never abundant down in the subway. Even at an ISO of 400 and a very wide aperture, this restricted me to a slow shutter speed, approaching the limit of what I can shoot handheld and still yield a sharp image. The benefit here is that the slow shutter speed allowed for motion in the cymbals, drumsticks, and even slightly in the drummer as he bobbed his head to the beat. This combines to create a sense of energy and movement that would have been lost at a higher shutter speed.

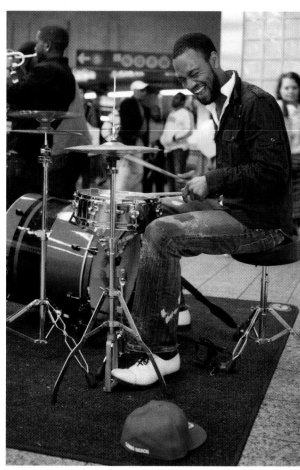

Focal length 35mm; ISO 400; aperture f/2.5; shutter speed 1/50; May 4:51 p.m.

The Shot

For this shot of classical guitarist Don Witter, Jr., I got close enough so that he spilled out of the frame. I shot at an angle that included the departing subway train. For all their utility, most subway stations are quite dreary. Take advantage of any opportunity to include color and movement. I shot this at the Grand Army Plaza station in Brooklyn. Two of the station's greatest attributes are its ample lighting and wide, unobstructed platform. In the few minutes that I shot here, I was able to capture the guitarist from a variety of angles. That kind of freedom is rare underground. When you find it, take full advantage.

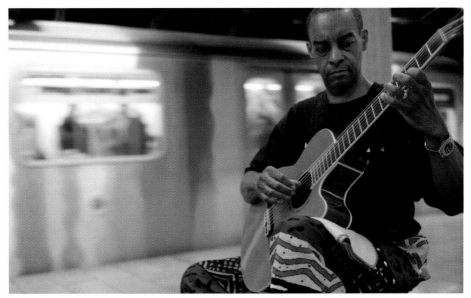

Focal length 35mm; ISO 400; aperture f/2.5; shutter speed 1/50; August 8:58 a.m.

 Musicians play when the crowds are at their peak. Your best bet for catching a subway performance is to visit stations during the morning and evening rush hours or during lunch.

Getting There

For a list of official performance locations in the subway system, visit www.lirr.org/mta/aft/muny/locations.html.

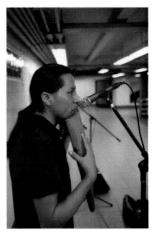

Peruvian musician.

 When to shoot: afternoon

Red Hook Park

Brooklyn's Red Hook Park has been a weekend draw in the Latino community for more than 30 years. And it all started with pickup soccer games. Friends and family of the players would often prepare home-cooked meals to enjoy after the game. In time, the food became an attraction in its own right. Today, the park offers a family-friendly atmosphere, organized league games, and the most authentic Latin cuisine you'll find. Foodies from all over the city make the pilgrimage for tacos, pupusas, and huaraches, among other delights. Many of the vendors use recipes handed down from generation to generation. And nearly everything is less than $10. This combination of great food at affordable prices is too much for any food lover to resist.

The Shot

The soccer field closest to the food trucks has a full day's schedule of matches on the weekends, so finding a game to photograph is no problem. The best location from which to shoot is from behind the endline, just to the side of the goal. Before deciding on which end of the field you should set up, spend some time just watching the game. In some games one team will dominate, advancing the ball toward their opponent's goal repeatedly. Setting up behind the goal receiving the most action will greatly increase your opportunities for an exciting shot. The players and the ball move quickly. Set your camera to shutter priority mode and select a shutter speed of 1/1000 or faster to freeze the action.

Focal length 200mm; ISO 200; aperture f/5; shutter speed 1/1000; August 5:24 p.m.

The Shot

New Yorkers discovering great food at good prices tend to be a happy bunch. This makes them great candidates for picture-taking. In this portrait I got close enough so that my subject fills most of the frame and the food on the plate remains a prominent element. This is a simple shot, but one that obviously required asking for her permission. By stating the reason I wanted to photograph her and working quickly, I was able to capture a series of natural and relaxed expressions. The smile in this particular exposure makes it a keeper.

Focal length 35mm; ISO 200; aperture f/8; shutter speed 1/125; August 3:34 p.m.

Ecuadorean flag.

Red Hook food vendor.

Getting There

The food vendors at Red Hook Park operate on the weekends from 10:00 a.m. until 7:00 p.m. To get there, take the 2, 3, 4, or 5 train to the Borough Hall station in Brooklyn. Exit on Court Street and take the free shuttle bus to IKEA. From the IKEA stop, follow Beard Street to Columbia Street and turn left. Make a right on Bay Street and walk alongside the park to Clinton Street.

When to shoot: evening

Tango in Central Park

Is there anything more romantic than a summer tango in Central Park? What began in 1997 with a small group of tango lovers carrying a boom box into the park has turned into a summer ritual that attracts devoted dancers as well as admiring spectators. You'll find beginners learning the basics alongside seasoned dancers who imbue the tango with the grace and charm for which it's known. You'd never know it, but the vast majority of the couples you see here are partners only on the dance floor. They meet at the park on Saturdays and then head their separate ways. Apparently, what happens in the tango stays in the tango.

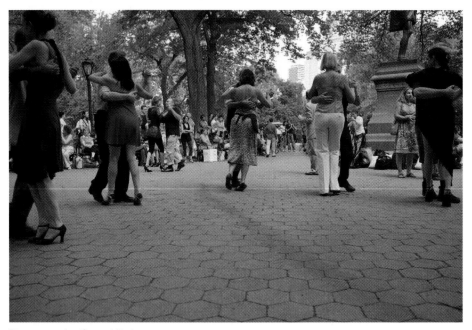

Dancers at the Central Park tango.

The Shot

As soon as I saw this couple, I knew I had to take their photograph. After getting their permission, I followed them as they danced. This shot emphasizes both the intimacy and energy of the tango. The elegant embrace with legs splayed and the sensuality of an exposed back make for a memorable shot.

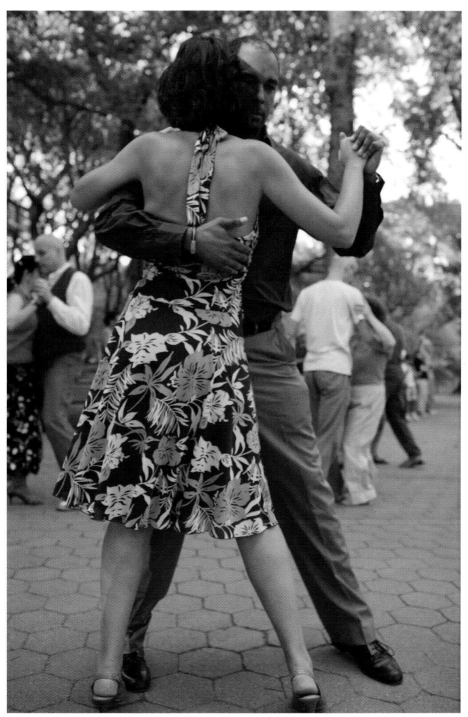

Focal length 35mm; ISO 400; aperture f/3.5; shutter speed 1/125; August 6:39 p.m.

The Shot

Like real estate, photography is about location, location, location. In this shot I wanted to focus on the beauty of Central Park as the perfect setting for a summer evening tango. I chose this particular spot because the sun had just descended below the tree line, giving a nice, warm glow with gentle sunlight peeking through the branches. I waited for a couple to move into the spotlight. As soon as these two came by, I knew I would have a great image. Note the shadow of the high heels and legs spilling out of the frame.

Getting There

The Central Park tango sessions are held on Saturdays and run from June through September. The action takes place from 6:00 p.m. to 9:00 p.m. at the Shakespeare statue at the south end of The Mall's Literary Walk. Take the 6 train to 68th Street/Hunter College. Walk east to Central Park and enter at 66th Street. For more information, visit www.spiceevents.net/tango_cp_sssp.html.

Focal length 35mm; ISO 400; aperture f/5.6; shutter speed 1/100; August 6:36 p.m.

 When to shoot: night

Times Square

If there's any parcel of real estate in Manhattan that needs no introduction, it's undoubt-edly the junction at Broadway and Seventh Avenue, otherwise known as Times Square. The area got its name when the *New York Times* opened its office on 42nd Street. Although the newspaper has since relocated, the original building at One Times Square is known to millions as the location for the famous ball that drops on New Year's Eve. Times Square has undergone a radical transformation over the last 13 years. Gone are the X-rated theaters and peep-show booths that used to dominate the area. In their place are theme restaurants, chain stores, and television studios. The Disney-fication of Times Square has its critics, to be sure. But one undeniable outcome has been the huge increase in tourist traffic. At night, the area comes alive and beats with the pulse of nonstop energy and excitement. Broadway, bright lights, and huge crowds—this is the New York everyone imagines.

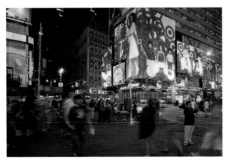

42nd Street and Seventh Avenue.

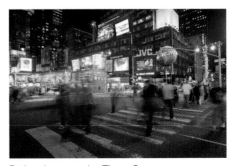

Pedestrians crossing Times Square.

The Shot

The shot may be a cliché, but traffic moving at night through Times Square is a guaran-teed winner when you're trying to convey the fast pace of the city that never sleeps. Cross 45th Street at Seventh Avenue and set up your tripod at the small traffic island in the mid-dle of the street. Facing south, adjust your camera so that One Times Square is in the cen-ter of the frame. The key to this shot is to use a shutter speed slow enough to blur the traffic for a sense of energy and motion. If traffic is moving at a steady clip, speeds any-where from 1/30 to 1/2 should suffice. You'll definitely want to take multiple shots with an eye toward capturing distinctive vehicles zooming by. In this shot you've got a taxi, a double-decker bus, and a city bus moving through the frame at the same time.

 The best photo ops in Times Square happen at night. When the sun goes down, Broadway lights up literally and figuratively like few other places in the world.

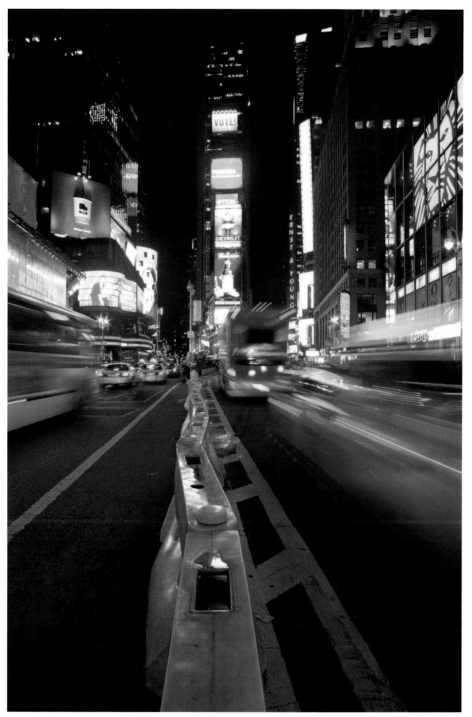

Focal length 20mm; ISO 200; aperture f/8; shutter speed 1/3; August 9:14 p.m.

The Shot

An interesting and seldom used perspective on Times Square can be had from the subway entrance on the north side of 42nd Street. Set up your tripod in the far corner near the wall so you don't impede anyone's progress. Set a slow shutter speed so that pedestrians are blurred a bit as they pass by. Make sure to include the illuminated subway sign listing all of the trains that stop in the station. Shots like this work best when the immediate fore-

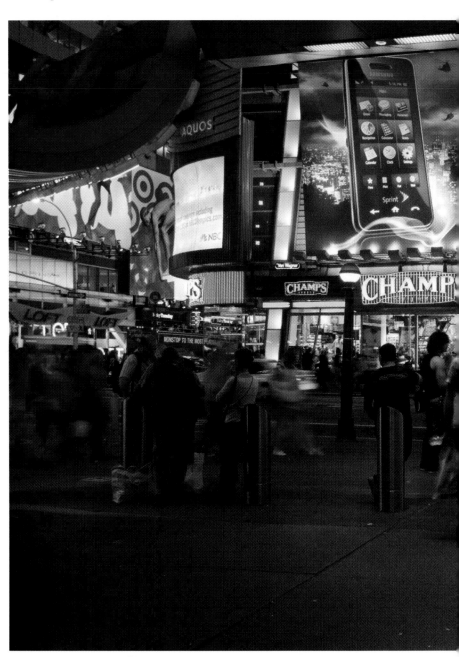

ground is empty. You get an unobstructed view of the scene. Catch passengers entering the station just as they reach the metal barriers. Any closer, and they will become so much larger than everything else in the scene as to be a distraction.

Getting There
Take the 1, 2, 3, 7, A, C, E, N, or R train to the 42nd Street/Times Square station.

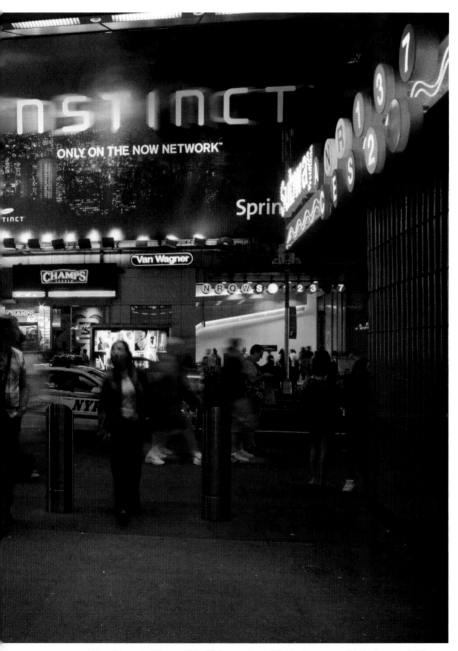

Focal length 20mm; ISO 200; aperture f/8; shutter speed 1/4; August 9:35 p.m.

When to shoot: afternoon, evening

Union Square

To be young and hip in New York means, among other things, hanging out in Union Square. Located just blocks away from the ultra-hip neighborhoods of Chelsea and Greenwich Village, as well as the New York University and the New School campuses, Union Square is a natural gathering spot for the under-30 crowd. But thankfully, there's also plenty to do for those born before 1980. A wildly popular Greenmarket features fresh produce from upstate farms as well as local artists selling their work. Fine dining and high-end shopping options abound in the surrounding neighborhood. Union Square has long been a venue for social and political protests as well. You'll find a bit of everything here, along with the chance to blend in seamlessly with real New Yorkers.

The Shot

This shot is at the southern end of Union Square facing 14th Street between Broadway and University Place. The steps at the edge of the park are a popular place to chat, read a book, or simply watch the world go by. I guessed that this would be a good location to wait for something interesting to happen. Once this woman came into view, I fired off a number of shots until she exited the frame. I had pre-focused on the area just behind her, turning the usual rules of composition on their head. Here, it's the subject that is out of focus. In this case it works to give her a sense of motion against a sharply rendered background. The shot here is my favorite of the bunch because she is walking, cigarette in hand, just past the sign for the Forever 21 clothing store across the street.

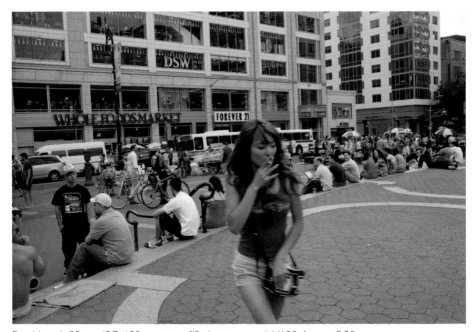

Focal length 35mm; ISO 100; aperture f/8; shutter speed 1/100; August 5:28 p.m.

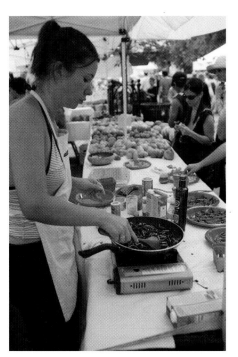

Cooking up samples at the Greenmarket.

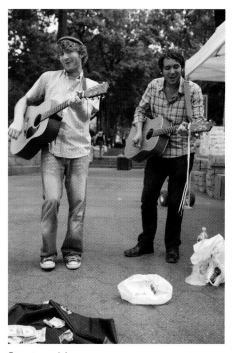

Street musicians.

The view from a vendor's booth.

The Shot

My theory on photographing people is that the more outlandishly they are dressed, the happier they will be to have their picture taken. I approached this artist selling his designs at the Greenmarket. And sure enough, no sooner had I asked to take his picture, and he struck about 10 different poses. In this one he shrewdly shows off his custom-designed jacket.

Getting There

Union Square extends from 14th Street to 17th Street between Broadway and Park Avenue. Take the 4, 5, 6, N, R, or Q train to the 14th Street/Union Square station.

Focal length 35mm; ISO 100; aperture f/5.6; shutter speed 1/160; August 12:28 p.m.

Chinese New Year Parade.

CHAPTER 3
Events

As the song says, New York is the city that never sleeps. With so much happening on any given day, there is really no bad time to visit. You're assured of great photo opportunities year round. But even for jaded New Yorkers who've seen it all, there are annual events, celebrations, and festivities so special that we mark their dates on the calendar with anticipation. Whether it's a celebration of cultural pride, a gathering of world-class athletes, or simply an excuse for a big party, this city is host to a number of events around which you may wish to plan your visit. In this chapter, we'll explore the best of these annual happenings and learn how to commemorate them with great photographs.

Shooting Like a Pro

Photographers on vacation are a breed apart. While most people travel to relax and avoid stress, we carry the burden of documenting once-in-a-lifetime opportunities. Everyone's got tales of the one that got away—a great shot that was foiled either by mechanical or human error. This is especially painful when shooting an event, because once it ends there's no chance for a do-over. Pros have learned through hard-earned experience how to maximize the chances of getting the perfect shot. Wanna know their secrets? Well, here are three. Know your equipment. Plan ahead. Anticipate the action. Simple as these may sound, putting them into practice can be the difference between a memorable moment and a missed opportunity.

The Gear

Today's cameras and lenses are among the most advanced tools in the history of photography. There's simply not a lot of bad equipment out there. There are undeniably, however, some tools better suited for particular tasks than others. Knowing the strengths and limitations of your equipment enables you to bring the right tool for the job. Sporting events, for example, demand telephoto lenses and fast shutter speeds. In the shot of tennis player Andreja Klepac, a 200mm lens was needed even though I was sitting courtside, no more than 15 feet away from her. The lens coverage was wide enough to include the ball but had enough reach so that you can see the concentration on her face as she prepares to hit her backhand. A wide aperture is often necessary when using a telephoto lens. It allows for a fast shutter speed, freezing the motion of everything in the shot. It also blurs the crowd in the background, keeping the viewer's attention on the player. This shot was a fairly simple one to take, but would have been impossible without the appropriate equipment.

Andreja Klepac's backhand.

The Plan

Behind most great images lies a good deal of planning. The first task is simply finding a good spot from which to photograph. After all, no amount of fancy equipment will help if you're stuck three rows deep in a crowd. To secure an unobstructed view at any event, plan to arrive well before the action starts. Then, before you even take a shot, spend some time observing your subjects. If it's a parade, scout for the most colorful and photogenic floats or costumes. These are the ones you'll want to follow closely. When covering a tennis match, observe the tendencies of the players. A serve-and-volley specialist will come to the net often, so you may want to prefocus your lens on the net area. Wait for the player to come to the net, and you can quickly capture sharp photos of his or her split-second reactions. Use your time wisely by seeking out locations where photogenic opportunities are most likely to present themselves. Many festivals, for example, have booths devoted to kids' activities, such as games, face painting, and storytelling. These provide great opportunities to photograph adorable smiling faces.

Take some time before the event to make a shot list detailing subjects and views you would like to capture. You may want crowd scenes, close-ups of participants, or detail shots of food or clothing. Consult this list during the shoot, checking off items as you go. You'll come home with a variety of images and perspectives.

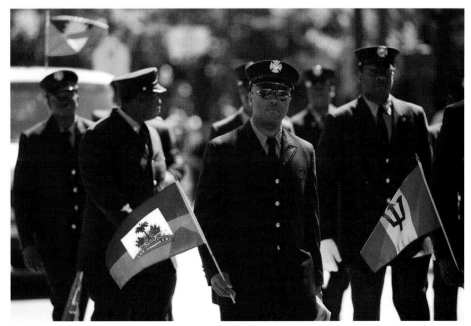

Parade marchers.

When to shoot: morning, afternoon

Cherry Blossom Festival

If you'd like to welcome spring with a taste of Japan, the Brooklyn Botanic Garden offers its popular Sakura Matsuri (Cherry Blossom Festival). This annual event celebrates Japanese art, music, dance, and of course, the cherry blossoms that dominate the garden's Cherry Esplanade. The festival features more than 60 events and performances ranging from origami classes to DJs spinning the latest in J-pop. The Garden is a joy to visit year round but is at its most spectacular when its 220 cherry trees reach peak bloom. But don't neglect the rest of the horticulture on display here. The Brooklyn Botanic Garden contains 52 acres and is home to more than 10,000 different types of plants from around the world.

The Shot

The Sakura Matsuri offers a range of activities. But you may want to visit just before or after the festival to photograph the Cherry Esplanade without the crowds. The first hour of each day is always the least crowded. In this shot I arrived just after a morning rain. The overcast sky offers soft, even light. The Cherry Esplanade features two double rows of Kanzan trees, one of the most popular double cherry varieties. Set up just at the entrance of either row and compose the shot so that the first set of trees extends to the edges of the frame. This draws the eye right through the thicket of blossoms. Using a wide-angle lens allows you to get very close and shoot low to the ground, filling the top of the frame with overhanging blossoms and eliminating as much of the dull gray sky as possible. Tripods are permitted in the garden, and the use of one will greatly aid in symmetrical compositions such as this one.

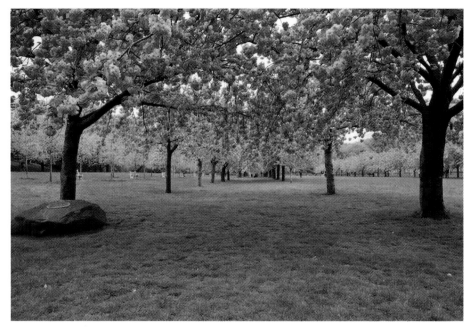

Focal length 24mm; ISO 100; aperture f/8; shutter speed 1/25; April 11:43 a.m.

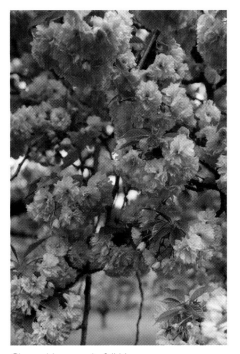

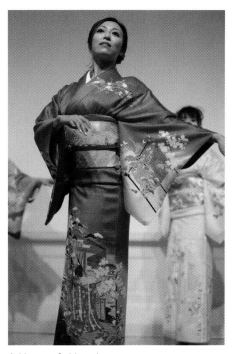

Cherry blossoms in full bloom.

A kimono fashion show.

A visitor shows off her cherry blossom tattoo.

The Shot

The central element of the Japanese Hill-and-Pond Garden is a 1-1/2 acre pond that can be viewed at various vantage points along the garden's meandering pathway. In this shot I included the distinctive orange torii, which signifies the presence of a shrine nestled in the grove of pine trees behind it. You want to shoot on a day with patchy clouds, which will at various times diffuse the direct light of the sun, keeping the contrast between the garden and sky in a manageable range. Placing the torii in the far left of the frame with the towering pine trees behind it creates a pleasing contrast to the sky in the center of the frame and is echoed by the foliage on the right. Including two visitors as they stroll past in the distance emphasizes the large scale of the garden.

Focal length 35mm; ISO 100; aperture f/8; shutter speed 1/125; May 11:17 a.m.

 The Cherry Blossom Festival occurs on a fixed date. But the timing of the actual bloom varies somewhat each year. Fortunately, the garden offers a helpful CherryWatch status map online at www.bbg.org/exp/cherries/map.html. This will let you track the trees' status from the first buds through the fall of the flowers.

Getting There

The Brooklyn Botanic Garden opens at 8:00 a.m. during the week, 10:00 a.m. on weekends, and is closed on Mondays. The main entrance is on Eastern Parkway. Take the 2 or 3 train to the Eastern Parkway/Brooklyn Museum station. Admission is $8. The Cherry Blossom Festival takes place each year in late April or early May. For a complete list of events and activities during the festival weekend, visit www.bbg.org/exp/cherries/sakura.html.

A Samurai perfomer.

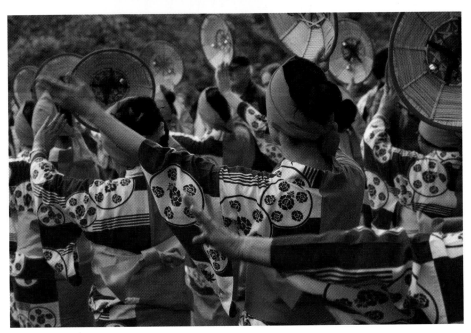

The traditional Flower Hat Dance.

When to shoot: afternoon, evening

DanceAfrica

Over the Memorial Day weekend, the sights, sounds, and rhythms of the African conti-
nent fill the air in Fort Greene, Brooklyn, for the annual DanceAfrica festival. The event is
sponsored by the Brooklyn Academy of Music, a world-renowned arts institution that is
the cultural hub of Brooklyn. The festival combines performances from dance and music
troupes with a vibrant outdoor bazaar. Vendors sell food, crafts, and colorful clothing that
celebrate the heritage of African culture. Also part of the festival is a popular film series
that showcases the work of directors both here and abroad exploring a range of issues
addressing the African diaspora. This is a great combination of food, culture, and scintillat-
ing performances—and an excellent way to mark the beginning of summer.

A selection of carvings.

The Shot

The festival stages most of its performances inside the Brooklyn Academy of Music's
Gilman Opera House. But there are free outdoor performances that occur alongside the
bazaar. Arrive ahead of the scheduled performance time so you can secure a spot at the
head of the crowd. In this shot I got low, shooting from one knee. This allows the dancers
to fill most of the frame. Dance is about movement. Notice how the dancer's right foot is
blurred even at a shutter speed of 1/250. Combine this with a sharp focus on her face and
her flowing dreadlocks, and you convey the energy and vitality that make dance such an
exciting art form.

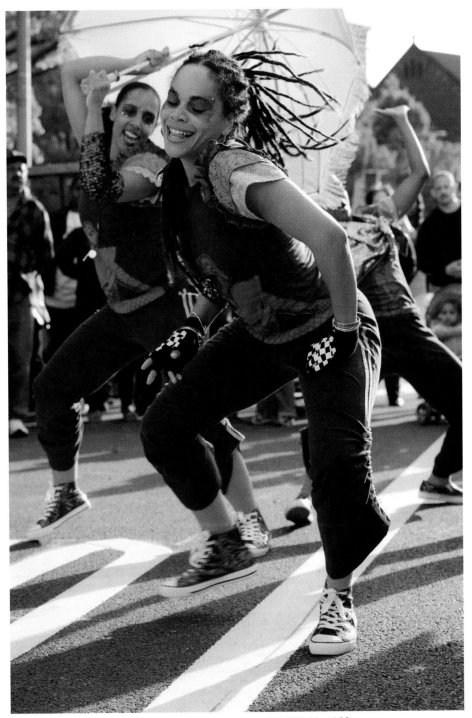

Focal length 85mm; ISO 400; aperture f/6.3; shutter speed 1/250; May 6:23 p.m.

Face painting.

The Shot

A great place to capture color is among the vendors' stands. Strolling past this display of bracelets, I knew I had to take a picture. With so many items on display, the most important decision is where to direct the viewer's attention. Shooting from just a few feet away with a relatively wide aperture forced me to choose a plane of sharp focus. Everything in front of and behind this plane is out of focus. I focused my lens on the layer of gemstone bracelets that run across the middle of the frame. This is the area with the most saturated colors and is a great location to direct the viewer's attention. The out-of-focus foreground and background give the image a sense of depth that brings order to what would otherwise be a chaotic jumble of elements.

Focal length 85mm; ISO 100; aperture f/5; shutter speed 1/250; May 2:31 p.m.

 For a great photo op at any festival, seek out the face-painting booth. You'll find colorful faces like the beautiful butterfly on the facing page, who are only too happy to pose for a picture.

Getting There

The DanceAfrica festival takes place over the Memorial Day weekend. The outdoor bazaar runs along Ashland Place between Flatbush Avenue and Lafayette Avenue. Take the 2, 3, 4, 5, B, D, M, N, or Q to the Atlantic Avenue station. For more information and festival dates, visit www.bam.org.

Colorful garments.

When to shoot: morning, afternoon

Mayor's Cup Handball Tournament

Walk past any of the city's large playgrounds in the summer, and you'll be serenaded by the constant *thwack* of a blue ball being smacked against a large grey wall. Handball is a quintessential New York City game. It's fast, physical, and often accompanied by a lot of trash-talking. The game and its participants form a classic New York City subculture where devotees young and old come together to hone their skills. One of the best opportunities to experience handball is at the Mayor's Cup tournament, held every summer in Central Park. The competition is intense, with up-and-comers challenging established legends. Handball may fly under the radar, lacking the wide appeal of basketball or baseball, but the skill and athleticism on display at this citywide tournament are a testament to the dedication of these players.

Spectator.

Match play.

The Shot

In this shot of a doubles match, I was positioned just off the court, only a few feet out of bounds. Getting a shot at the beginning of the point is a lot easier because the server starts from the same location. I got down on my knees, approximating the height at which the player strikes the ball. As he prepared to serve, I fired off a burst of exposures. The one you see here was the most effective of the entire sequence. The ball is in the middle of the frame, and the server's arm is cocked, ready to accelerate into the ball.

Focal length 35mm; ISO 100; aperture f/6.3; shutter speed 1/500; July 12:55 p.m.

Focused on the shot.

The Shot

The action is very fast in handball, with players darting around the court. Forget about tracking them with your lens. Instead, prefocus on a particular area of the court and wait for players to enter the frame. One of the best vantage points from which to shoot is from the edge of the wall itself. The out-of-bounds line is set back a few feet from this edge, so the chances of getting hit with a wayward shot are pretty minimal! Before taking a single shot, I spent some time watching this match to get a feel for where the players end up on the court. Players are often arranged front to back, with the person hitting the ball in the foreground. I used a fairly wide aperture to maintain a fast shutter speed. This meant a shallow depth of field, so I knew that my focus needed to be on the foreground player. Having already

chosen an area for the composition, with the lens focused on the foreground I was able to quickly fire off a series of shots as the player prepared to strike the ball. This particular shot is successful for three reasons. The ball is still in the frame, the player striking the ball is in sharp focus, and the player in the background is poised to react to the upcoming shot.

Getting There

The Mayor's Cup Handball Tournament takes place in mid-July. Admission is free. The adult divisions are contested in Central Park's North Meadow courts. Take the B or C train to the 96th Street station. For tournament dates and other information, visit www.icha.org.

Focal length 85mm; ISO 100; aperture f/5; shutter speed 1/500; July 9:34 a.m.

When to shoot: morning

New York City Marathon

Each year on the first Sunday in November, New York City hosts marathon runners from around the world. First-timers and decorated professionals alike start their morning at the Verrazano Bridge in Staten Island for 26.2 miles of running. Organized by New York Road Runners, this event was born in 1970 with 127 runners confined to loops around Central Park. Today, the race accommodates more than 39,000 entrants on a course that weaves through all five of the city's boroughs. More than half a million dollars in prize money is at stake for the elite runners, who will complete the race in well under 2 1/2 hours. It can be argued, however, that the true spirit of the marathon is found in the ordinary people from all walks of life who have committed themselves via months of dedication and training to simply finishing the race. For those of us more inclined to don a camera vest than running shorts, this event provides a wealth of photo opportunities. The entire route is accessible to the public, and New Yorkers turn out in droves as ebullient cheerleaders, celebrating the efforts of athletes from around the globe and around the corner.

The Shot

My favorite spot to take pictures of the lead runners is in Fort Greene at the corner of St. Felix Street and Lafayette Avenue. Arrive 20 minutes or so after the elite runners start the race, and you'll have your choice of spots to shoot from along the curb. This location is at Mile 8, and you can expect the top runners to arrive less than 40 minutes into the race. In this shot, the lead pack of elite male runners has just turned onto Lafayette Avenue. These guys are running at a fast clip, so to come away with a sharp image I had to do two things.

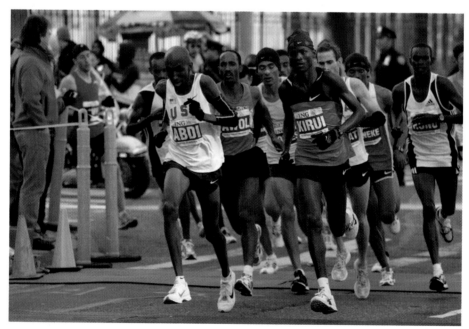

Focal length 200mm; ISO 200; aperture f/4.5; shutter speed 1/800; November 10:27 a.m.

First, I put the camera in shutter priority mode and set a fast shutter speed to freeze their motion. Experience has taught me that I have only a couple of seconds to shoot before the runners have put me in their rearview mirror. There would be no time to fiddle with framing the shot or focusing the lens. So my second task before the racers arrived was to frame a composition and manually focus my lens at that spot on the course. When the runners approached I simply fired off a rapid sequence of exposures as they entered and exited the viewfinder.

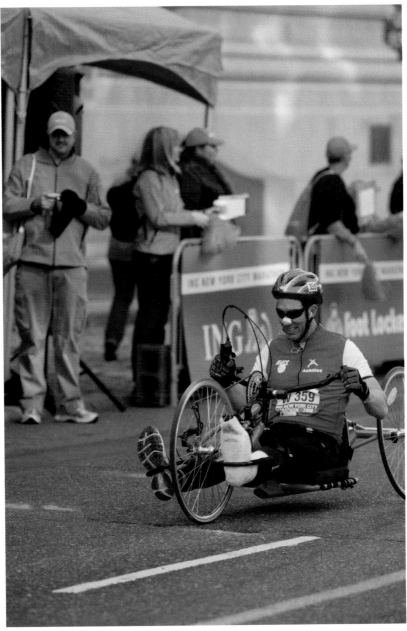

A handcycle competitor.

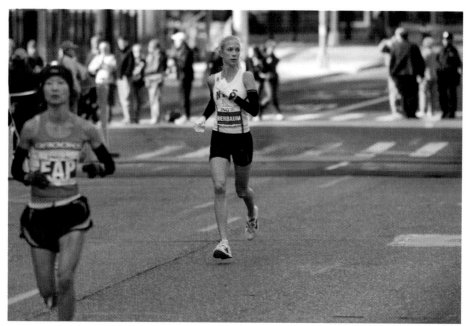

Stealing a glance at Mile 8.

The Shot

The nice thing about shooting a marathon is that you have world-class athletes and regular folks alike competing on the same course, offering a wide variety of photo ops. Once the lead runners had passed, I walk a few blocks up Lafayette Avenue to the corner of South Elliot Place. Along this residential block the crowds are sparse enough that you can easily find an unobstructed view along the sidewalk. Crouching on one knee, I captured these two runners engaged in conversation just before they ran past me. Colorful fall foliage fills the upper third of the background and offers a pleasing contrast to the multitude of runners behind our subjects.

Getting There

To watch the race in Fort Greene, take the 2, 3, 4, 5, D, N, or R train to the Atlantic Avenue/Pacific Street station in Brooklyn. Exit the station at Flatbush Avenue and follow Ashland Place one block to Lafayette Avenue. Race start times are staggered, with the professional women leaving a half hour ahead of their male counterparts. For more information about the marathon, visit the New York Road Runners website at www.nyrr.org.

An elite runner makes her way.

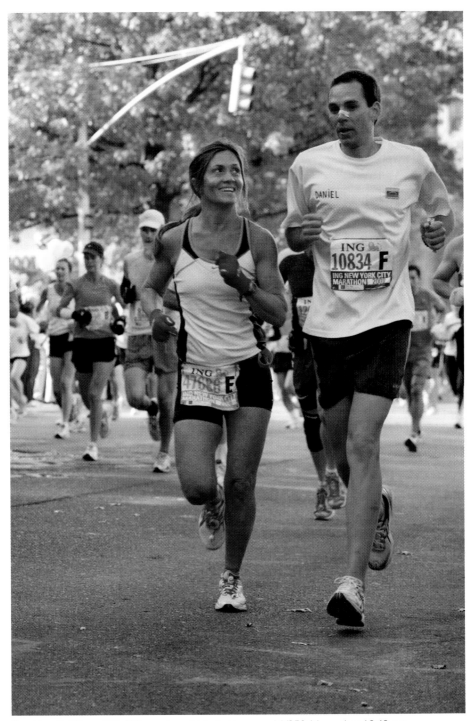

Focal length 85mm; ISO 400; aperture f/4.5; shutter speed 1/250; November 10:48 a.m.

When to shoot: morning

New York International Auto Show

For car enthusiasts, the start of spring officially begins with the transformation of the Jacob K. Javits Center into a massive showroom of polished chrome for the New York International Auto Show. Begun in 1900, this event is North America's oldest and best attended car show. It brings together more than a thousand different models from dozens of manufacturers that cover a wide range of tastes—and income brackets. Sedans, hybrids, and SUVs share space with vintage autos, limited-edition sports cars, and professional racing models. You also get a peek into the future of automobile design with the ever-popular concept cars. For car shoppers, the show is a great way to compare features among an incredibly wide variety of vehicles. But of course, there's nothing wrong with simply coming to ooh and ahh at exotic cars that cost more than your house. Whatever the case, if four wheels and an engine get your heart racing, mark this event on your calendar.

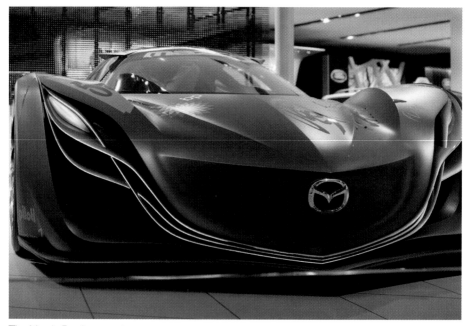

The Mazda Furai concept car.

The Shot

This is a classic perspective from which to shoot a sports car. At a 10- to 15-degree angle, looking along the side profile, I'm kneeling close to the front bumper with a wide-angle lens. This elongates the shape of the car, allowing it to fill most of the frame. Again, staying low eliminates most of the specular highlights created by the overhead lighting. A relatively small aperture ensures that sharp focus extends from the front headlight to the side-view mirror. The Suzuki logo in the background adds a nice touch of interest that complements the main subject.

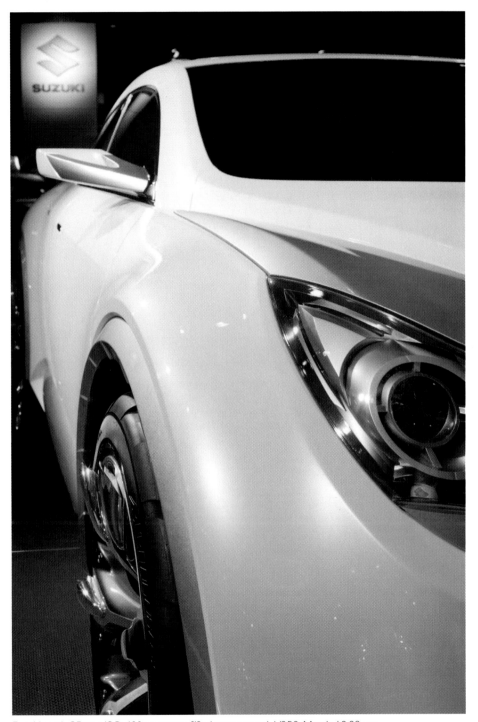

Focal length 35mm; ISO 400; aperture f/8; shutter speed 1/250; March 10:08 a.m.

The Shot

Shooting cars in a convention center presents one particularly significant challenge. The harsh overhead lighting puts clusters of reflections on the cars that can ruin any photo. To minimize this you need to get low. You'll spend a lot of time on your knees or elbows looking for angles that show the least amount of reflections. An additional benefit of a low vantage point is that the lines and curves of the cars can be emphasized much more dramatically, as seen in this shot of a custom Lamborghini Murciélago. To get the shot I was almost prone to the ground, propped up by my elbows. Giving the wheel such prominence in the composition enables the curves and rounded edges of the car frame to echo the wheel well's circular shape. I got as close as I could with a wide-angle lens to emphasize the dramatic shape of the car's front end. This shot screams sleek, sexy sports car, even with only part of the automobile visible. Be on the lookout for subtle touches like the matching blue of the tire trim and disc brake. In a convention center, you're not likely to have compelling backgrounds, so shoot at a wide aperture to blur the background and keep the viewer's attention on the subject.

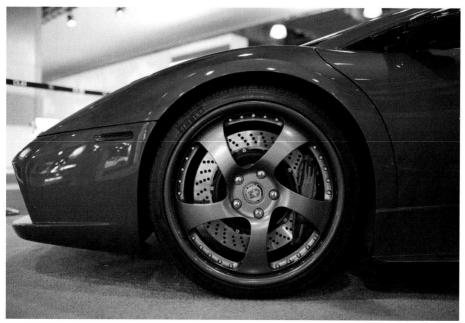

Focal length 35mm; ISO 800; aperture f/2; shutter speed 1/60; March 10:11 a.m.

 The Auto Show attracts more than 1 million visitors in just two weeks. So once the doors open for general admission, the only shots of cars you'll get will include the backs of people's heads. Fortunately, there's a Members Express pass, available for $20, that allows you entry to the show floor an hour early on weekends—a must-have. For show dates and details about the early admission pass, visit www.autoshowny.com

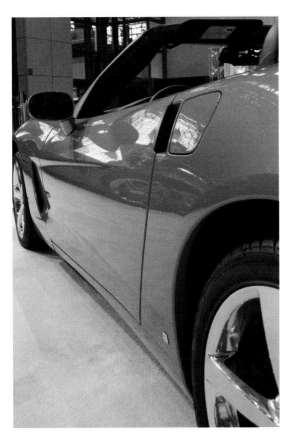

Getting There

The Jacob Javits Center is located at 655 West 34th Street. Take the A, C, or E train to 34th Street/ Penn Station. Walk west on 34th Street for three blocks.

Corvette convertible.

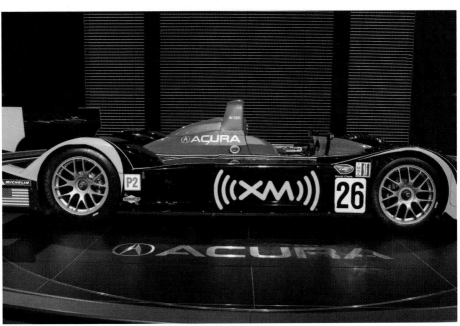

Acura's Le Mans race car.

When to shoot: morning

Tugboat Race

Few visitors think of Manhattan as an island, let alone contemplate the role its waterways have played in the development of the city. So it's understandable that the lowly tugboat does not merit a lot of attention. Each year, though, at the end of summer, the Working Harbor Committee seeks to remind us of the important role that tugboats continue to play, by sponsoring the Great North River Tugboat Race and Competition. Dozens of actual working tugboats cruise up the Hudson River to take part in a series of maritime events that draw larger and larger crowds each year. The highlight, of course, is the race, where freshly scrubbed and decorated boats steam down the river to claim the title of the fastest tugboat.

The Shot

A river full of tugboats can be enjoyed from the shore. But for the best photo ops you'll want to purchase a ticket on the Working Harbor's spectator vessel. This tour boat sails into the river, getting you up close and personal with the tugboats as well as providing great views of the city. In this shot, I got a great frontal view of the Davis Sea tugboat. I waited for the tugboat to get fairly close so that it filled the frame, its shape echoing the skyscrapers in the background. This composition also eliminates a good deal of sky, which at this time of day exhibits harsh light. This is just one of many shots you will be able to capture during the day's events.

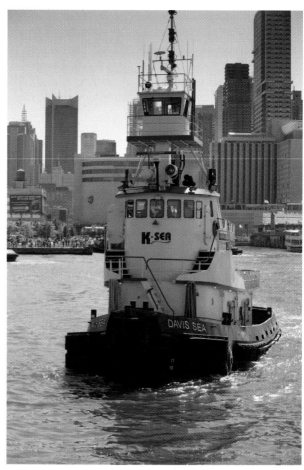

Focal length 85mm; ISO 100; aperture f/5.6; shutter speed 1/400; August 11:24 a.m.

The Shot

This shot of the U.S. Army Corps of Engineers tugboat is a pleasant contrast to the previous image. The size and position of the boat calls for a horizontal format. Photographing west toward the New Jersey side of the Hudson River yields a rich blue sky. This view is also absent the skyscrapers that dominate midtown Manhattan, offering instead a lush tree line dotted with houses. The large flag offers a nice splash of color.

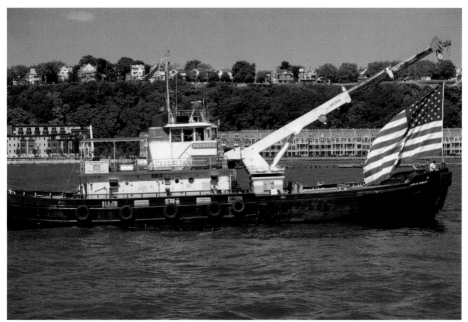

Focal length 85mm; ISO 100; aperture f/5.6; shutter speed 1/1000; August 11:06 a.m.

Getting There

The spectator vessel for the tugboat race departs from Pier 83. Tickets are $35 for adults. Take the 1, 2, 3, 7, 9, A, C, E, N, Q, or R train to the Times Square 42nd Street station. Walk west on 42nd Street to Twelfth Avenue. For more information about the race and to purchase tickets, visit www.workingharbor.org.

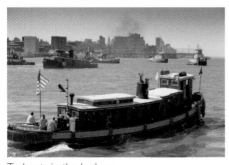

Tugboats in the harbor.

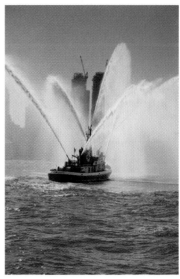

A fireboat celebrates the race.

 When to shoot: morning, afternoon, evening

U.S. Open

For two weeks between August and September, New York City is home to the world's greatest tennis players. The USTA Billie Jean King National Tennis Center is the site of the U.S. Open, the final grand-slam event of the calendar year. If you're a tennis fan, there is no better time to visit the city. From top stars such as Roger Federer and Serena Williams, to journeyman players who had to qualify to make the main draw, the U.S. Open offers a smorgasbord of championship tennis.

The Shot

To get a shot from this vantage point of the Grandstand Court, enter Louis Armstrong Stadium and take the stairs to the top level. On the eastern side of the stadium there is a connecting walkway that looks directly down on the Grandstand Court. From here, a 400mm lens lets you come in tight on the player serving on the north end of the court. In this shot I created a composition dominated by the green area outside the baseline. Firing a burst of successive shots during her serve gave me lots of interesting shots. I chose this one because she is spilling out of both sides of the frame with just a hint of the blue playing surface in the lower-right corner. By compressing the distance between the player and the court, the telephoto lens reduces the sense of depth, giving the image a stark, abstract feel. Note also the abundance of triangular shapes formed in this image, lending it a graphic, rather than purely photographic, feel.

THE OPEN ON THE CHEAP

Of the many adjectives used to describe the experience of attending the U.S. Open, inexpensive will never be one of them. Ticket prices for the most coveted seats run well into the hundreds of dollars. And in the food court, a hamburger and soda can set you back almost $15. But there is an economical option for tennis lovers on a budget. For each of the first eight days of the tournament, you can buy a grounds pass for $46. This pass allows you all-day admittance, and you can watch matches on any of the 18 outside courts as well as in Louis Armstrong Stadium and the more intimate Grandstand Court. Seating is first-come first-serve, so with a little planning (and good fortune), you can watch great early-round matches just a few feet off the court. Matches between the top-seeded players are usually played in Arthur Ashe Stadium, which requires a separate (and very expensive) ticket. But don't despair. You can still see the game's biggest stars up close by heading over to the practice courts. Players book time there to hit with their practice partners before matches and on off-days. And there is bleacher-style seating just outside the fence for fans to enjoy it all. There are no great food bargains here, but if you hop back on the 7 train to any stop between 90th Street and 74th Street, you end up in Jackson Heights, a mecca for authentic ethnic cuisine. This neighborhood offers a staggering number of restaurants, serving the finest Latin American, Korean, and South Asian food anywhere in the city—all at prices that can't be beat.

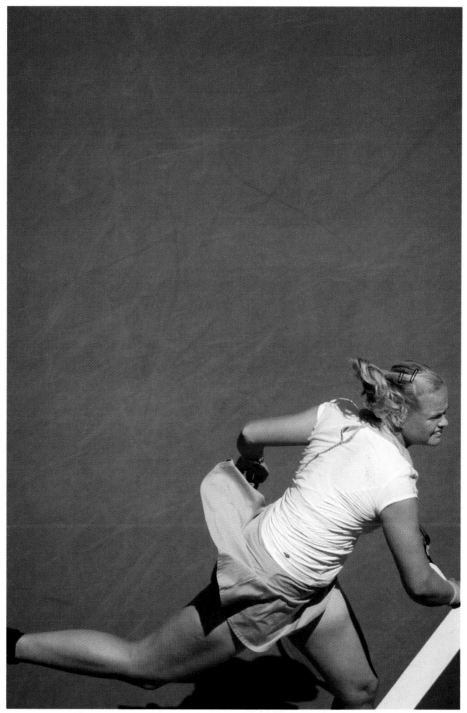

Focal length 400mm; ISO 200; aperture f/7.1; shutter speed 1/1000; August 1:13 p.m.

The Shot

In the beginning of the chapter I spoke of the importance of arriving early. It made this shot possible. The Grandstand Court seating is on a first-come first-serve basis. I knew that I wanted to get shots of Jo-Wilfried Tsonga, one of the tour's most promising young players. So I arrived at the court while the preceding match was still in progress. And sure enough, at the conclusion of the first match, as fans left their seats, I spotted an empty chair in the first row behind the baseline—a dream for every tennis fan. Each game Tsonga played on the opposite side of the net gave me countless opportunities to shoot him head-on. For a number of shots I decided to prefocus on the baseline area in an attempt to capture some powerful groundstrokes. This shot is effective because he has just struck the ball, which is still in the picture. As a bonus, he was in the middle of the court, and the U.S. Open logo appears just behind him.

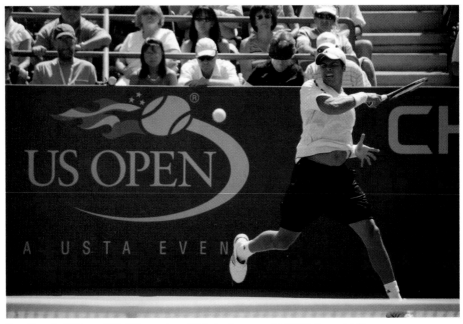

Focal length 400mm; ISO 400; aperture f/5.6; shutter speed 1/1000; August 1:01 p.m.

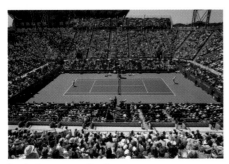

Louis Armstrong Stadium.

Spectators watching a match on one of the outer courts.

Dinara Safina on the practice courts.

Getting There

The U.S. Open is held at the USTA Billie Jean King National Tennis Center in Queens. Take the 7 train to the Willets Point/Shea Stadium station. For scheduling information and ticket purchases, visit www.usopen.org.

> **N O T E**
>
> Backpacks are not permitted at the U.S. Open and must be checked prior to entering the grounds. Waist packs and small shoulder bags are the best bet for carrying your camera equipment.

U.S. Open ballboy.

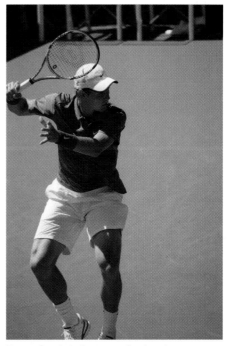

Tomas Berdych lines up a forehand.

When to shoot: night

Village Halloween Parade

If you're in town on Halloween and you want to experience the creativity of fun-loving and uninhibited New Yorkers, make plans to attend the annual Village Halloween Parade. What started in 1973 as a small neighborhood walk organized by a local puppeteer has become an internationally renowned extravaganza. Visual and performing artists turn out intricately crafted floats, costumes, and puppets that celebrate this nocturnal holiday in grand style. The parade makes its way along Sixth Avenue from Spring Street to 21st Street and is open to anyone who shows up in a costume. Best of all, the parade organizers are extremely accommodating to photographers. On the parade's website, you can apply for a press badge that affords you access to the staging area as well as the actual parade route. All they ask in return is that you share some of your pictures in their online photo gallery after the event. If you thought Halloween was just for kids, the spectacle of New York's largest nighttime parade is one you will not want to miss.

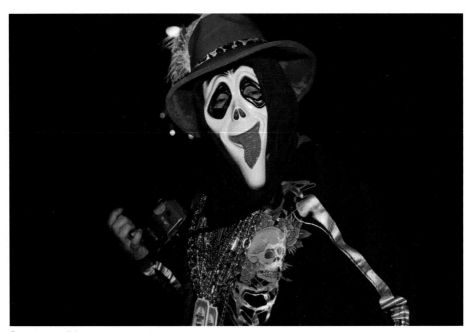

Scary, yet stylish.

The Shot

For both participants and spectators, this parade is all about having a good time. Entertainment abounds—from live bands and outrageous costumes to, yes, a glow-in-the-dark hula-hoop exhibition. Using an external flash unit mounted on the hot shoe of my camera, I was able to freeze the dancer even at a relatively slow shutter speed. The ambient light emanating from the hula hoop creates soft streaks of color that convey a sense of motion. A few distinct elements make this particular image stand out from the many others I took of the same scene. The foreground dancer is turned away from the camera, her head spilling out of the frame for a more dynamic shot. Dancers who appear to emerge out of a solid black backdrop flank her on both sides. And finally, the three hula hoops appear as interlocking rings, providing a sense of compositional unity.

Focal length 35mm; ISO 400; aperture f/4; shutter speed 1/60; October 7:02 p.m.

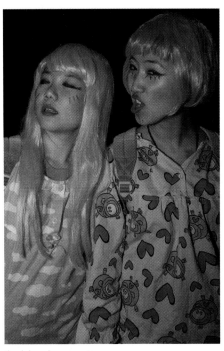

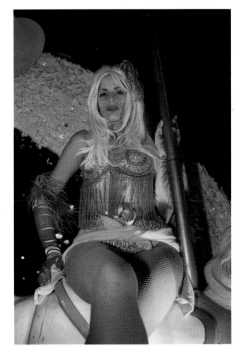

A pink pajama party.

A bit of burlesque.

The Shot

The parade is famous for its giant puppets that hover high above the crowds. In the staging area was a collection of skeletons that would soon be worn via harnesses by some of the dozens of parade volunteers. Noticing this skeleton in a bowing position, I created a composition where it extends diagonally across the frame, almost as if it were praying. It's important to remember that the illumination from a camera-mounted flash will only reach so far into the distance. Here, the large areas of black behind the subject actually help to separate it visually from a rather busy background.

Getting There

The staging area for the parade is at Spring Street and Sixth Avenue. Take the C or E train to the Spring Street station. The parade gets underway at 7:00 p.m. For parade details and information on obtaining a press badge, visit www.halloween-nyc.com.

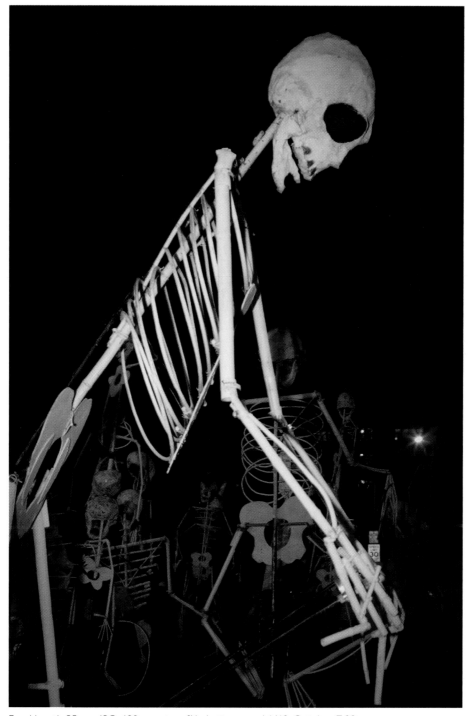

Focal length 35mm; ISO 400; aperture f/4; shutter speed 1/60; October 7:08 p.m.

When to shoot: afternoon, evening

West Indian Carnival Parade

New York City may seem like an unlikely place to experience sights and sounds of the Caribbean. But on Labor Day, the West Indian Carnival Parade brings a Mardi Gras atmosphere to Brooklyn that is not to be missed. With thousands of participants and nearly two million spectators, this is by far the largest parade in the city. Lively music, stunning costumes, and mouth-watering food are on tap for this celebration of Caribbean culture and pride. This event is perfect if you're shy about asking permission to photograph someone. During the parade, three separate people came up and suggested that I take their picture!

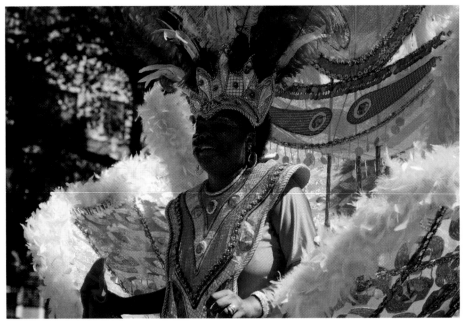

A lavishly costumed participant.

The Shot

As with any parade, you don't want to be stuck on the sidewalk behind a barricade. Arrive about an hour before the 11:00 a.m. start time and head to the staging area located on Rochester Avenue and Eastern Parkway. Once inside the barriers, stay on Eastern Parkway, where you can watch final preparations being made. As the parade gets underway, simply continue along the parade route taking photos of both the participants and spectators. You will hardly be the only photographer in the parade. I took this shot while she was posing for a photographer on my right. Instead of shooting directly behind him, I remained off to the side and got what's known as a 3/4 pose, where her body is angled away from the camera. Another benefit of my location was that I avoided shooting directly into the sun.

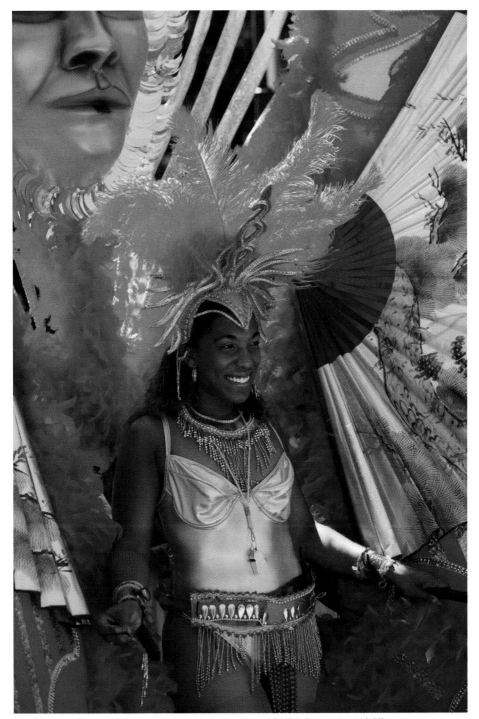

Focal length 85mm; ISO 200; aperture f/4; shutter speed 1/400; September 12:27 p.m.

The Shot

There are so many wonderful costumes on display in this parade that it's hard to choose what to shoot. But this participant's elaborate costume, complete with skull, was too good to resist. He was very gracious about posing—there were no fewer than three other photographers surrounding him. I framed this shot so that the spear and shield both spilled off the edges of the frame while his face, the area of sharp focus, occupied the center of the frame. Oh, and I should mention there were four others dressed in identical outfits. An embarrassment of riches for any photographer!

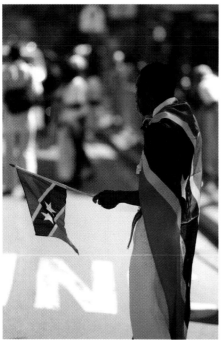

St. Kitts pride.

Spectators showing their colors.

Getting There

The parade runs along Eastern Parkway from Utica Avenue to Grand Army Plaza. To reach the staging area, take the 3 or 4 train to the Crown Heights/Utica Avenue station in Brooklyn. For information about the parade visit www.wiadca.com.

 Harsh midday sunlight is a photographer's nemesis. Your camera's auto exposure settings can be easily fooled when background areas are significantly brighter than your subject. The result is a severely underexposed image. For situations where you cannot avoid this type of lighting, use a telephoto lens and fill the frame with your subject, avoiding the overly bright background elements altogether.

Focal length 200mm; ISO 200; aperture f/3.5; shutter speed 1/400; September 12:20 p.m.

English garden trellis at the Staten Island Botanical Garden.

Chapter 4
Urban Oasis

No one visits New York to get away from it all and savor the quiet life. But the constant hustle and bustle of big city life can wear down even the hardiest of travelers. When a brief respite from the asphalt jungle becomes a priority, the good news is you don't have to leave the city for your timeout. Opportunities for a more tranquil experience are just a subway or ferry ride away. In this chapter, we'll go island hopping, explore medieval relics, marvel at exotic animals, and view immaculate gardens. These places may not resemble the gritty New York streets seen in the movies, but they are an integral part of daily life, offering New Yorkers the chance to recharge their batteries before heading back to the rat race.

Shooting Like a Pro

Few things separate travel photography from vacation snapshots more definitively than the quality of light. Much of the life of a travel photographer is spent simply waiting for the best light. The most dramatic lighting often occurs when the sun is lowest in the sky. The times just before and after sunrise and sunset are known among photographers as the *magic hours*. It's well worth your time to shoot at least once during this dramatic light. It often makes the difference between a good image and a stunning photograph.

Of course, as a tourist, you're limited to visitors' hours for access to many locations. In these cases, pay close attention to the weather forecast and choose your subjects accordingly. In the sidebar "Weather Wise," you'll find advice for making the most of whatever lighting is available.

The Gear

With the exception of the zoo, the photo opportunities in this chapter allow for a variety of focal lengths. Create wide shots that put your subject into a larger context or shoot tight to crop out distracting background elements. No matter what lens you use, however, there are two things you can do to ensure you come away with the sharpest possible photos.

Unless their use is prohibited or impractical, use a tripod and cable release. You'll eliminate camera shake, and you can stop down the lens to its sharpest aperture. This is usually a few stops smaller than the widest f/stop and thus requires a slower shutter speed. With my own equipment, I've found f/8 to be the sweet spot for ultimate sharpness. Your mileage may vary.

For the sharpest possible handheld images, the rule of thumb is to set a shutter speed no slower than the reciprocal of the lens focal length. A 50mm lens, for example, would require a shutter speed of 1/50 or faster in order to minimize camera shake. With a 200mm lens, you'll need a shutter speed of 1/200 or faster.

The Plan

One of the biggest favors you can do for your own photography is to think about the types of images you want to come away with *before* you actually start shooting. Give some thought to potential groupings of images and to the story you ultimately want to tell. To highlight the historical significance of a location, for example, include some detailed close-ups that show its age and avoid telltale signs of modern day life, such as street signs and automobiles. If the photo opportunity is about vibrant city life, get shots of people enjoying themselves. Shoot both interiors and exteriors when possible. Mix close-ups with wide-angle shots. Experiment with both horizontal and vertical compositions. Capturing a variety of perspectives and compositions that contribute to a single story will make your images much more interesting to any audience.

WEATHER WISE

You can't control the weather during your visit. But you can tailor what you shoot and when you shoot it to specific weather conditions for successful images. Overcast days, particularly just after a heavy dose of rain, provide an excellent opportunity to shoot foliage. The soft, even light eliminates distracting shadows. Colors appear more vibrant. Close-ups of flowering plants dappled with raindrops make compelling images. Just make sure to crop the monotonous gray skies from your compositions.

For outdoor scenes where you want to include large areas of sky, keep an eye out for days with fast-moving clouds. The combination of a blue sky and puffy clouds can be striking. Best of all, the ever-changing cloud formations offer a variety of backgrounds from a single location.

On bright, sunny days with no clouds in sight, try to shoot in the late afternoon as the sun is making its descent. Shoot with the sun behind you, and there will be long, sculpting shadows that add depth to your subject.

You can avoid the vagaries of daily forecasts altogether by shooting at night. The biggest challenge you'll face is finding an appropriate exposure to balance illuminated objects like street lights with those that are not directly lit. Don't rely solely on your camera's auto exposure settings. Bracket a few shots and look at the histogram on the LCD screen. You want as much data as possible to fit within your camera's highlight and shadow range.

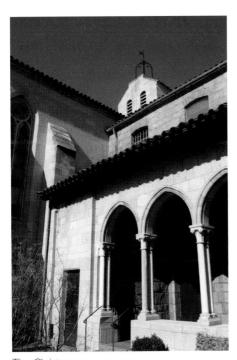

The Cloisters.

Gardening truck.

 When to shoot: afternoon, evening

Battery Park City

One of the most pleasant walks you can take in Manhattan without feeling like you're in the city is to follow the shoreline of the Hudson River through Battery Park City. Nearly 36 acres of public space have been created to allow pedestrian access to the waterfront. Start in Wagner Park on the pathway just behind the restaurant Gigino. Continue to South Cove, where the rugged landscaping and wooden fixtures create a naturalistic shoreline environment.

Wagner Park.

South Cove.

Up next is the Esplanade. This stretch offers a wonderful opportunity for people watching, as tourists, joggers, and families enjoy the waterfront views. The yachts docked in North Cove just behind the World Financial Center Plaza are impressive to say the least. For much less expensive recreation, bring some friends and head to the volleyball court. The Irish Hunger Memorial, shown a bit later in this section, is a landscaped remembrance of the great potato famine of 1845. End this walking tour at Rockefeller Park, where you can take a well-deserved rest before heading back to the city streets. Exit at Chambers street and walk east to West Broadway for the nearest subway.

The Esplanade.

North Cove Yacht Harbor.

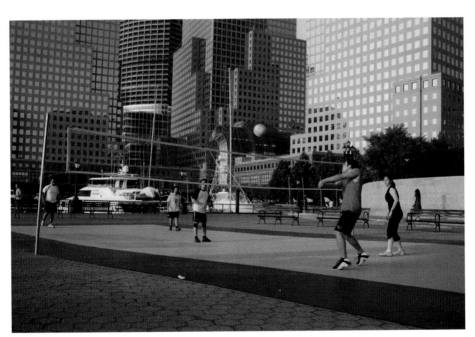

Volleyball game at North Cove.

The Shot

This shot is more reminiscent of an island resort than Gotham City. To get it, walk toward the northern end of South Cove. Turn around and place the tree line in the upper-left corner of the frame. Use a 35mm lens or wider so you can include open water at the opposite side of the frame. Wait until late in the day as the sun is preparing to dip below the horizon. Otherwise, the contrast between the sky and shoreline will be too great.

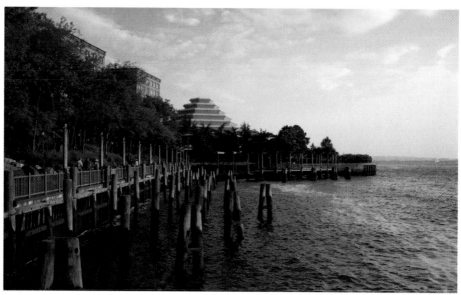

Focal length 35mm; ISO 400; aperture f/8; shutter speed 1/400; June 7:32 p.m.

Walkway in Wagner Park.

The Shot

The Irish Hunger Memorial is a landscaped setting that rises on a cantilevered base 25 feet above the ground. Coming up the entrance ramp, set up just behind the stone wall so that only the sky is visible. Use a wide-angle lens to take in as much of the scene as possible. During the afternoon the sun will be behind you, so the contrast between sky and foreground should not be too great. After you get the shot, be sure to continue wandering up the path. You'll get a terrific view of the Hudson River.

Focal length 24mm; ISO 100; aperture f/8; shutter speed 1/250; June 1:52 p.m.

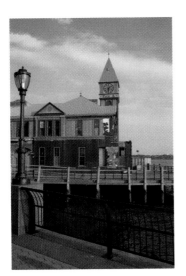

Pier A.

Getting There

To begin the walk, take the 4 or 5 train to the Bowling Green station. Walk west along Battery Place toward Pier A.

 When to shoot: morning

Bronx Zoo

Founded in 1899, New York City's flagship zoo remains a signature attraction, drawing more than two million visitors each year to the Bronx. The zoo features more than 4,000 different animals spread among 265 acres of parkland. Under management of the Wildlife Conservation Society, the Bronx Zoo was a pioneer of cage-less enclosures, opting to let animals roam freely in carefully designed naturalistic habitats. Today, the zoo places a high priority on fostering and encouraging instinctive animal behavior by emulating conditions and opportunities that exist in a species' natural habitat. Public education about conservation and threats to biodiversity are hallmarks of the zoo's exhibits. The zoo itself plays an important role in maintaining biodiversity by successfully breeding endangered species. Two of its most popular and photographically rewarding exhibits are Tiger Mountain, home to big Siberian cats, and Congo Gorilla Forest, which includes multiple generations of lowland African gorillas. Make these among your first stops during your visit.

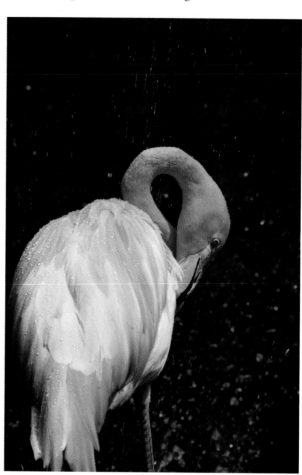

Pink flamingo cooling off.

 To catch animals at their most attentive and playful, arrive during one of their daily feeding and/or training sessions. Check the zoo's website at www.bronxzoo.com/bz-plan_your_visit/bz-feedings for the daily schedule.

SHOOTING AT THE ZOO

To those who've never tried it, getting great photos at the zoo must seem like a piece a cake. With so many exotic animals all in one place, all you have to do is pick up the camera and start shooting, right? Not quite. To come away with stunning photos, you need to consider the following.

✳ **Bigger is better.** A telephoto lens is an absolute must. You'll only get but so close to these wild animals. And the most effective shots are essentially portraits, emphasizing some unique characteristic of the animal. A focal length in the 300–400mm range allows you to tightly frame an animal while excluding boring, zoo-like backgrounds. You want the animals to look like they're in the wild, not the Bronx.

✳ **Focus, focus, focus.** Telephoto lenses offer a shallow depth of field. Combine this with the fact that you're likely shooting at a wide aperture (to increase shutter speed), and you have an extremely narrow area of sharp focus. If there's one element that must be sharp, it is undoubtedly the eyes of your subject. With a telephoto lens, an animal that is 15 feet away need only move a few inches to slip out of focus. So continuously readjust focus as you shoot. You may find it easier and faster to focus your lens manually, as you'll constantly be making subtle adjustments while the animal moves.

Larger animals tend to move slowly, so one trick is to set up for a spot ahead of the animal's movement and prefocus so that when the animal appears in the viewfinder, only a small adjustment is needed to begin shooting.

✳ **Keep it steady.** Handholding a telephoto lens and avoiding camera shake is a tall order for any photographer. Many higher-end lenses come with an image stabilization feature that automatically counteracts camera movement, resulting in sharp images at lower shutter speeds. A monopod also comes in very handy. It's unobtrusive and easy to carry, yet takes the weight of the lens off your hands. And it still allows the flexibility to quickly change position. Using a monopod in combination with image stabilization can allow you to capture sharp images at shutter speeds two or three stops slower than you could without them.

✳ **Patience is a virtue.** All of the larger animals in the zoo are free-roaming. They go where they want, when they want. The least of their concerns is posing for you. You have to be extremely patient. Once you choose an animal to photograph, plan on spending a lot of time looking through the viewfinder, simply waiting for something interesting to happen. Eye contact, a show of teeth, interaction with another animal, and just plain goofy behavior all make for interesting photographs. Make the most of your visit by planning to cover just a few different animals and allowing ample time at each exhibit.

✳ **More storage.** With animals constantly on the move, you're going to have a high number of rejects. Out-of-focus shots, exposure errors, and poor timing can all add up to many gigabytes of images just to come away with a few keepers. Bring extra storage cards. You'll need them.

The Shot

Tigers can happily spend most of the day lounging in the grass. So to catch one on the move, you have to be prepared. The first thing that made this shot possible was that I arrived at the exhibit before a scheduled enrichment session, during which a trainer lures the tiger over to a training area. As the trainer began coaxing the tiger to come over, I aimed the camera for an area between where the tiger was lying and the eventual destination. Once the tiger started to move, I locked the exposure setting and set focus for a foreground object. Then I waited for the tiger to come into view. Fortunately (luck rewards the prepared), as the tiger headed forward, she stopped and turned to the side, offering an incredible profile. A quick and slight focus adjustment put the eyes in sharp focus, and I was able to fire off three quick shots. The one you see here had the best composition and angle of the face.

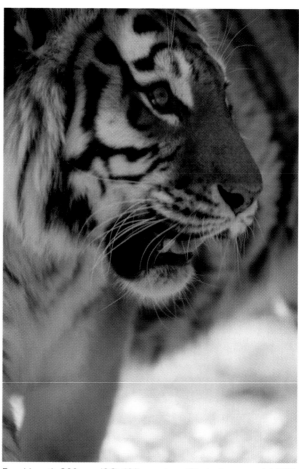

Focal length 300mm; ISO 400; aperture f/4; shutter speed 1/500; May 11:35 a.m.

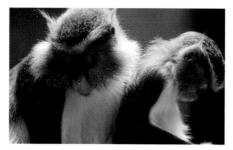

Wolf's Ear monkeys.

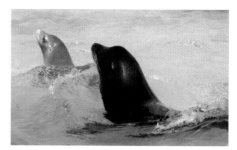

Sea lions.

Focal length 300mm; ISO 800; aperture f/4; shutter speed 1/500; May 12:57 p.m.

The Shot

At the Congo Gorilla Forest, there is a great viewing station where only a wall of glass separates you from a family of gorillas. While they are free to roam anywhere over 6.5 acres, these animals are quite curious, and the spectacle of dozens of visitors pressed against the glass often attracts a gorilla or two for some mutual staring. As this young gorilla settled down in a corner, inches from very excited visitors, I was able to take a few steps back and shoot at a slight angle to avoid reflections from the glass. The narrow view of the telephoto lens eliminated the backs of people's heads. I focused on the eyes and ran off a series of shots as his gaze, expression, and tilt of the head changed quickly over a matter of seconds.

Getting There

The zoo is open seven days a week from 10:00 a.m. to 5:00 p.m. (5:30 p.m. on weekends and holidays). To get there, take the 2 or 5 train to East Tremont Ave/West Farms Square. After exiting the station, walk north toward 179th Street on Boston Road to the Asia gate entrance. Admission is $15 for adults. For more information, visit www.bronxzoo.com.

Youngster at the Congo Gorilla Forest.

 When to shoot: dawn, afternoon, evening

Central Park

This 843-acre park, an enduring symbol of New York City, has the distinction of being the country's first public landscaped park. And make no mistake; this is very much a manmade creation. Landscape architects Frederick Olmsted and Calvert Vaux meticulously designed every square inch of the park. It took 20,000 laborers to reshape the existing swamps and bluffs into the terrain we know today. The park was officially completed in 1873, and its early use was dominated by the city's elite, who arrived by horse and carriage, luxuries far from the means of the poor and working class.

Today, New Yorkers of all walks of life come together for a wide range of events and activities. Standout events include the SummerStage series of free concerts that book musicians from around the world. And some of the hottest tickets of the summer are to see the A-list actors who show off their theater skills in the annual Shakespeare in the Park festival. Add to these attractions a zoo, playgrounds, baseball diamonds, plus the obligatory carriage rides, and you've got a park with something to offer everyone.

The Shot

Getting a great shot of Central Park's Reservoir couldn't be easier. Entering the park at East 90th Street, simply walk up the stairs leading to the runner's track, and a vista of the Upper West Side of Manhattan opens up before you. The most distinctive feature of this skyline is the double-towered Eldorado apartment building. Place that in the center of your frame. I shot this image at dawn, while lights along the reservoir's perimeter and in the buildings were still on. Use a lens of 35mm or wider to capture as much of the scene as possible.

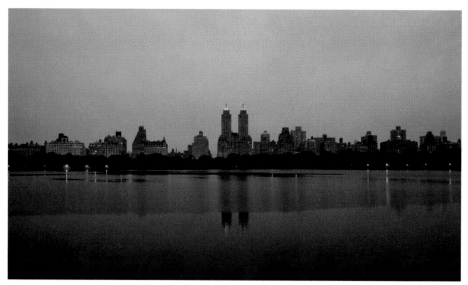

Focal length 35mm; ISO 200; aperture f/8; shutter speed 5 seconds; June 4:59 a.m.

The Reservoir's fountain creates ripples that spread across the water. For the classic shot with mirror-like reflections of the buildings, visit during the winter months when the fountain is turned off.

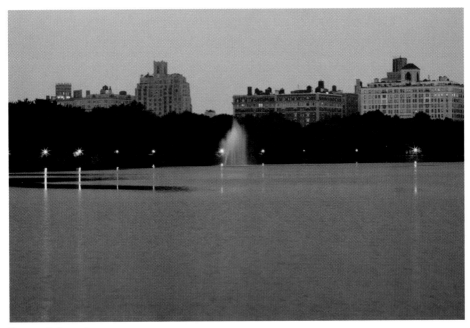

Reservoir fountain.

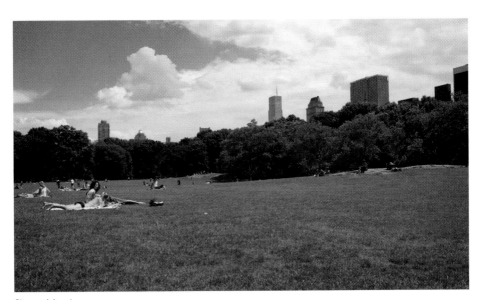

Sheep Meadow.

The Shot

The Conservatory Water has long been a gathering place for model-sailboat enthusiasts. You'll see everything from simple wind-powered sailboats to intricate and expensive radio-controlled versions. Set up at the southwestern edge of the water so that the Fifth Avenue apartment buildings loom in the background. It won't take too long before a boat sails near you. This shot works because it places a tiny object (the sailboat) in the foreground, greatly increasing its size relative to the background trees and buildings. Make sure to include the boat's reflection in your composition. One trick to shots like these is to set your desired composition and then wait for the action to happen. Here I placed the rightmost apartment building near the top-right corner of the frame. I wanted the green-roofed boathouse as a point of interest, so once the model boat appeared, I waited until it was near the center of the frame but shot before it obscured the boathouse. The ducks are an added bonus, and they can be found enjoying the park throughout the spring and summer months.

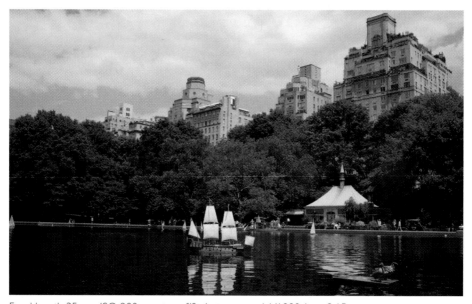

Focal length 35mm; ISO 200; aperture f/8; shutter speed 1/1000; June 2:15 p.m.

Pedicab ride.

Getting There

Central Park extends from 59th Street to 110th Street. To get to the east side of the Reservoir, take the 4, 5, or 6 train to the 86th Street station. Walk west to Fifth Avenue, head north to 90th Street, and enter at the Engineer's Gate.

To reach the Conservatory Water, take the 6 train to the 68th Street/Hunter College station. Walk west to Fifth Avenue and head north to the park's 72nd Street entrance. For more information about the park's events and attractions, visit www.centralpark.com.

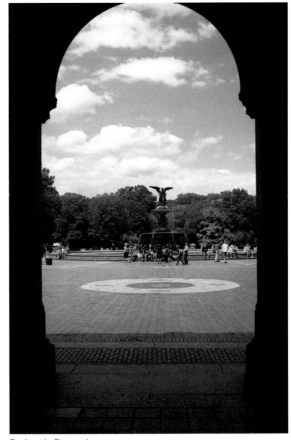

Bethesda Fountain.

When to shoot: afternoon

Chinese Scholar's Garden

The Chinese Scholar's Garden is just one of several distinct and wonderfully maintained gardens located on the historic grounds of the 83-acre Snug Harbor Cultural Center, the hub of Staten Island's arts and education programming.

Scholar's gardens were seen as an integration of philosophy, art, and poetry into a functional house and garden setting. This one is as authentic as they come. It was designed by a Chinese firm specializing in traditional garden design. All of the architectural materials were created in Suzhou, China, and highly skilled Chinese artisans were brought to Staten Island for the six months of construction. The result is an embodiment of the concept of manmade and natural beauty reinforcing one another to create a refuge from daily pressures. You don't need a deep understanding of the symbolic relationships of architecture and horticulture governing the design principles of such gardens to be in complete awe of these surroundings. Make sure that after you've taken your pictures, you indulge in at least a few moments of unhurried reflection in this one-of-a-kind setting.

The Shot

The essence of the scholar's garden exists in the relationship between the hand of man and that of nature. Passing through the Moon Gate of Uncommon Beauty, you can see this harmony clearly at play. Shoot from the zigzagging footbridge, and you can frame the horizontal undulations of the Meandering Cloud Wall against the vertical stalagmite rocks and lush foliage. Shoot with the sun behind you and set an exposure that maintains a rich blue tone in the sky without making everything else go dark. Wait for an actual cloud or two to move in just beyond the Meandering Cloud Wall, adding a final dimension of harmony to the image.

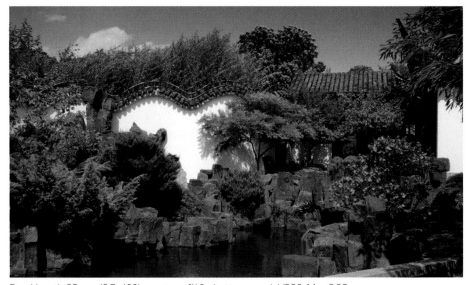

Focal length 35mm; ISO 400I; aperture f/18; shutter speed 1/250; May 3:23 p.m.

The Shot

Walking along the perimeter of the garden brings you to the Moon Embracing Pool, which is fed by a small waterfall. Get down low and shoot so that your vantage point is that of the curved pool. The overhanging tree provides a point of interest as the viewer's eye follows the water's path further into the picture. Again, the balance between architecture and natural elements is emphasized. The ivy-covered walls in both the foreground and background provide symmetry and again help draw the viewer into the center of the frame. The lower to the ground you get, the less sky will show at the top of the frame, so this is an excellent vantage point for overcast days as well.

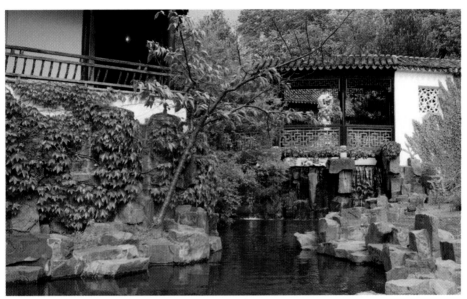

Focal length 35mm; ISO 400; aperture f/10; shutter speed 1/250; May 3:33 p.m.

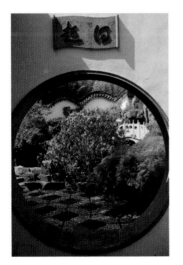

Getting There

The garden is open Tuesday through Sunday from 10:00 a.m. to 5:00 p.m. during the summer and noon to 4:00 p.m. during the winter. Staten Island can be reached by ferry service. Take the R or W train to the Whitehall Street/South Ferry station. Cross Whitehall Street to the Staten Island Ferry terminal. Ferry service is free, and boats leave every half hour. After reaching Staten Island, take the S40 bus to the Snug Harbor stop. Stop in the visitor center for a map that leads you to the garden. Admission is $5 for adults. For more information visit www.sibg.org/cg.html.

Moon Gate of Uncommon Beauty.

 When to shoot: afternoon

The Cloisters

A branch of the venerable Metropolitan Museum of Art, The Cloisters is devoted exclusively to medieval art and architecture. Designed to invoke the ideals of the Middle Ages, rather than faithfully replicate a preexisting structure, the building itself is a modern amalgam of Romanesque and Gothic styles, but does include architectural fragments from actual European churches and monasteries.

Set high atop a hill in Fort Tryon Park, The Cloisters opened to the public in 1938. You'd be hard-pressed to imagine a more appropriate setting for bringing this impressive collection of sculptures, tapestries, ceramics, and stained glass to life. The parkland on which The Cloisters sits, the museum's construction costs, and the funds to acquire the bulk of the collection were provided by John D. Rockefeller, Jr., who also donated the stunning collection of unicorn tapestries for which The Cloisters is best known.

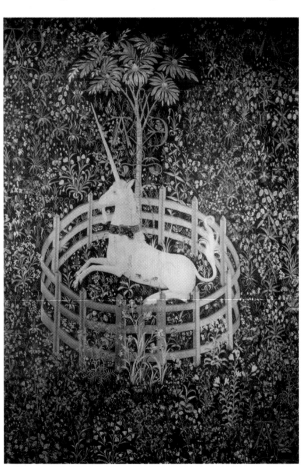

The most famous of the Unicorn tapestries.

 The Cloisters does allow the use of tripods on weekdays. Simply request a tripod pass at the information desk. Out of consideration for other visitors, keep all of your equipment under the legs of your tripod when shooting.

The Shot

The Cuxa Cloister incorporates ruins from an actual 12th-century abbey in France. It's located on the museum's main level, just off the Late Gothic Hall. The actual cloister, or covered walkway, surrounds an outdoor garden. But it's the architectural details that make this shot a winner. Set up your tripod so that the fountain at the far end of the hallway is centered in the frame. Use a wide-angle lens to emphasize the leading lines of the building's walls, which will draw viewers to the rear fountain. Set your focus and aperture so that everything from foreground to background remains sharp. This lets the viewers feel as if they could literally walk into the scene. The daylight coming through arches on the right side will be much stronger than the artificial illumination along the interior. Bracket your shots or manually adjust exposure so that details are not blown out between the arches. I shot this during the winter when crowds are extremely sparse. An additional benefit of this time of year is that garden plants are kept inside, adding a splash of color to the composition.

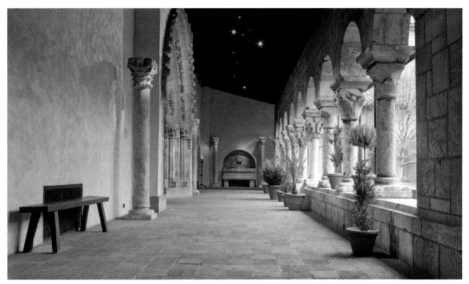

Focal length 20mm; ISO 200; aperture f/8; shutter speed 0.6 seconds; February 2:29 p.m.

The Shot

The limestone columns of the Saint-Guilhem Cloister also date from the 12th century and are among the pieces that made up the initial collection at The Cloisters. Located on the main level, this is the smallest of the museum's four cloisters. Enter through the Romanesque Hall in the northern section of the museum. Set up your tripod at the entrance to the enclosed garden, centered between the double set of columns. From this head-on view, the garden's fountain lines up directly beneath the center archway in the background. Expose for the light coming through the garden. This puts the foreground slightly in shadow, adding a sense of depth to the image. Use a wide-angle lens and set the camera back a few feet from the columns so that both foreground and background objects are in clear focus.

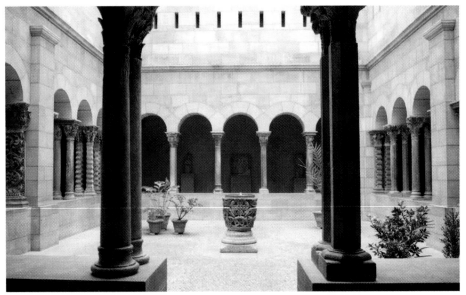

Focal length 35mm; ISO 100; aperture f/8; shutter speed 0.8 seconds; February 2:44 p.m.

Getting There

The Cloisters is open Tuesday through Sunday from 9:30 a.m. to 5:15 p.m. during the summer and closes at 4:45 p.m. during the winter. Take the A train to the 190th Street station and follow exit signs for Fort Tryon Park. Take the M4 bus one stop to The Cloisters' main entrance. Or walk north along Margaret Corbin Drive for approximately 10 minutes. Suggested admission is $20 for adults. For more information, visit www.metmuseum.org/cloisters/events.

Cobblestone driveway and arched entrance.

 When to shoot: afternoon, evening

Conservatory Garden

This six-acre garden is a hidden jewel of Central Park proper. The garden in its present form dates back to 1937 and contains not one, but three separate gardens representing distinct landscaping styles and fauna. The Central Garden features a long, open lawn anchored by a fountain and tiered hedges in the rear. Rows of crabapple trees form an alleyway along either side and offer a shaded spot for visitors to unwind. Just to the South is what's commonly known as the Secret Garden, named after the bronze figures that were inspired by Frances Burnett's classic children's book of the same name. The French-style North Garden is an ornate circular garden centered around a sculpture fountain called the Three Dancing Maidens. Each garden features a variety of seasonal flowers and plants so that from spring through summer, you're assured of amazing sights and smells in an intimate and peaceful setting that make New York City feel miles away.

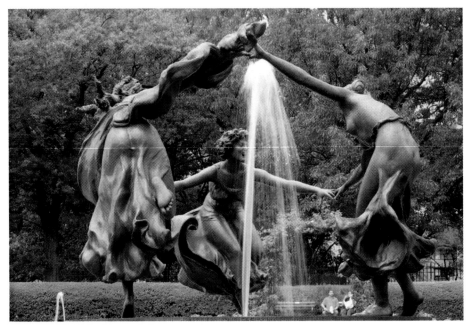

Three Dancing Maidens sculpture.

The Shot

In the middle of the English-style South Garden is a small reflecting pool and sculpture. From the far end of the pool, kneel along its stone edge. Shooting from a low position like this lets you capture the sculpture's reflection at the bottom of the frame while placing the overhanging branch so it is above the sculpture instead of obscuring it. Including people in shots like this adds great interest. And given that the sculpture is inspired by a children's story, it's an added bonus when kids can be shown taking in the scene.

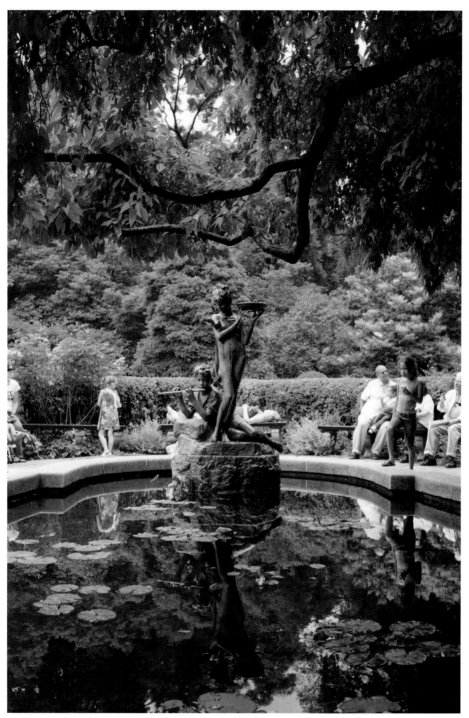

Focal length 35mm; ISO 200; aperture f/5.6; shutter speed 1/125; June 1:30 p.m.

The Shot

Upon entering the garden through the Vanderbilt Gate, this is the scene that greets you. On the steps just inside the gate, set up your tripod with the fountain in the center of the frame. To highlight the long expanse of the garden and make it even more dramatic, I used a 35mm lens instead of an ultra wide-angle focal length. With this narrower field of view, the sides of the hedges spill out of the frame, making the scene feel more dynamic. If the contrast between the sky and the foliage is too great for your camera to record in a single exposure, you have a couple of options. You can, of course, simply crop out the sky. Or you can take two separate exposures—one for the highlights and the other for the foliage—and use an image editing application such as Adobe Photoshop to blend the two exposures into a single image.

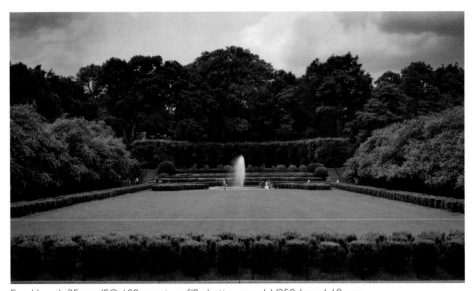

Focal length 35mm; ISO 100; aperture f/8; shutter speed 1/250; June 1:18 p.m.

Getting There

The garden is open daily from 8:00 a.m. until dusk. Take the 6 train to the 103rd Street station. Walk west to Fifth Avenue and enter the garden through the Vanderbilt Gate located between 104th and 105th Streets.

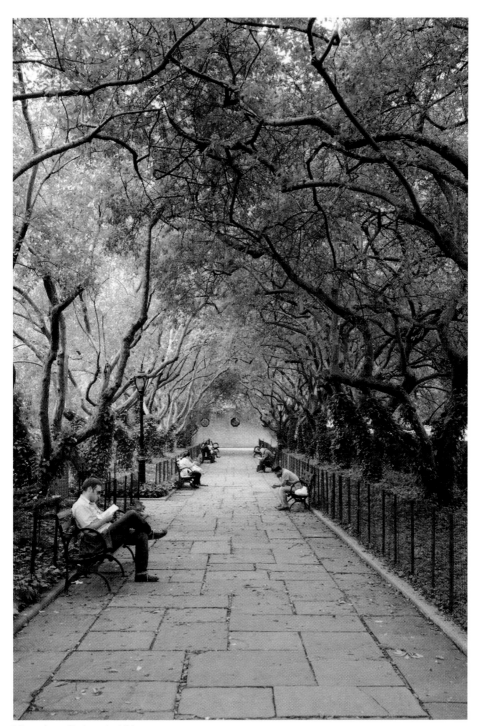

View along Crabapple Allées.

When to shoot: afternoon

Elevated Acre

The Elevated Acre is one of the more successful examples of privately owned public spaces. Developers are often allowed by the city to build beyond a given density on the condition that they provide an outdoor space for public use. In 2005, this space, located in the heart of the city's financial district, was completely redesigned to make it a more accessible and appealing destination. Hidden from street-level view, the Elevated Acre rises 30 feet in the air and overlooks the East River with stunning views of Brooklyn's shore and New York Harbor. A visit during lunch hour confirms the popularity of a river-front view combined with a well-tended garden. Here's a place where New Yorkers can take a break from the workday grind in style.

A waterfront view of Brooklyn from the Elevated Acre.

The Shot

The best way to convey the uniqueness of a manicured garden nestled among densely packed office buildings is to show them both in the same photograph. Stand midway up the sloped pathway and shoot facing the direction from which you entered. It's not necessary for the background buildings to be in focus. Our main subject is the foreground flowers and plants. So set a wide aperture and place focus toward the bottom of the frame. Once set up here, I waited for someone wearing colorful clothing to enter the scene and photographed while she was well out of the plane of focus.

Focal length 50mm; ISO 100; aperture f/5; shutter speed 1/125; June 1:39 p.m.

The Shot

This shot of the seven-tiered amphitheater is interesting largely because of the low angle from which it was shot. Kneeling down on the artificial grass places the top seating level high in the frame and eliminates any view across the river. You get a bold juxtaposition of sky and clouds against this urban garden landscape. This is a scene you can easily duplicate during lunch hour on any weekday in the spring or summer.

Focal length 50mm; ISO 100; aperture f/5; shutter speed 1/500; June 1:51 p.m.

Getting There

The Elevated Acre is located at 55 Water Street. Take the R train to the Whitehall Street/South Ferry station. Turn right onto Water Street. Look for the stainless steel placard, shown in the image of the Elevated Acre's entrance, and use the stairs or escalators.

Conversation along the boardwalk.

The Elevated Acre's street-level entrance.

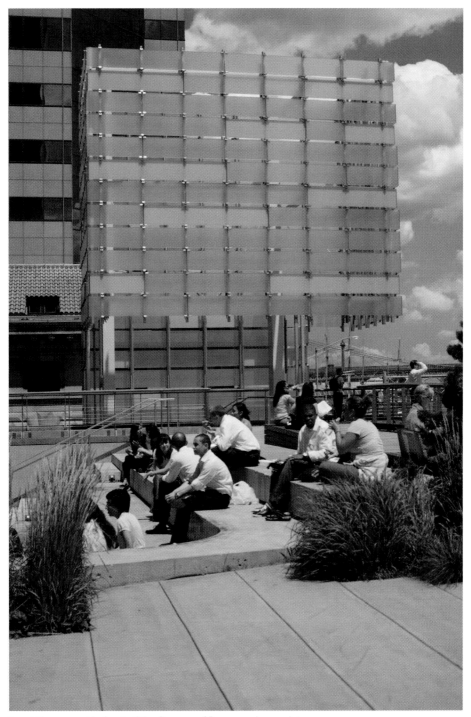

Lunchtime crowd in front of the Beacon of Progress glass sculpture.

When to shoot: afternoon

Governors Island

Governors Island served as a strategic military base from the early days of the American Revolution through World War I and II. At various times it has served as a supply base, a housing compound, and a stockade for prisoners of war. Although it is located just 800 yards offshore of Manhattan, the island remained an enigma to ordinary New Yorkers. Beginning in 2003, however, with a transfer of ownership between the federal and local governments, the island has been remade into a unique public destination. The island's historic buildings and fortifications are receiving long-overdue restorations. Acres of land are being converted for public use. Best of all, you can now explore this wonderful piece of history from the spring through fall via a free ferry service from lower Manhattan.

Whether you're a history buff eager to explore the city's military past, you crave idyllic parkland away from the noise and congestion of the city, or you simply want stunning views of the Manhattan skyline, Governors Island is a destination you won't want to miss.

Sculpture installation in Nolan Park.

Brick footpath in Nolan Park.

The Shot

This shot of Castle Williams requires a wide-angle lens. Set up your tripod just across the paved road from the castle and frame the shot so that the rounded edge of this historic armament is juxtaposed against the backdrop of the modern city skyline. You'll need to find a position that eliminates the overhanging branches of the tree behind you. To add an element of interest and scale, wait for a passing cyclist to enter the frame. It shouldn't take long, as the bike rental shop on the island does a brisk business. Watch for cyclists on the road between you and the castle, as well as along the rear of the castle at the edge of the water.

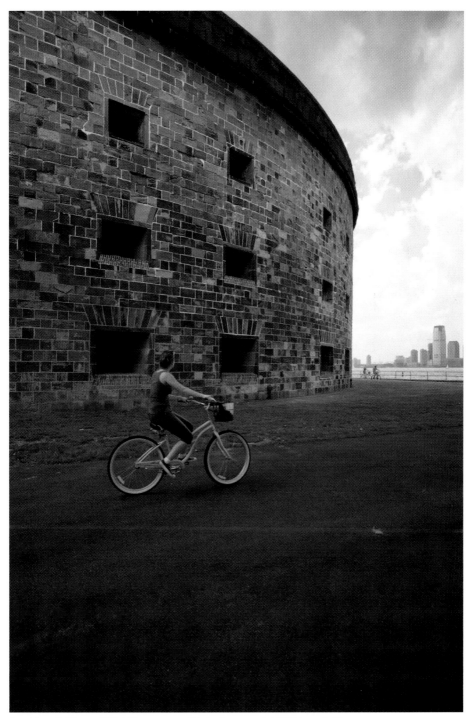

Focal length 20mm; ISO 100; aperture f/8; shutter speed 1/200; June 3:42 p.m.

The Shot

Fort Jay, the oldest structure on the island, has been one of the primary fortifications protecting New York Harbor since the late 18th century. The massive scale of the fort makes it impossible to capture in a single photograph, so I decided to focus on a detailed section of the outer wall. Enter through the gatehouse and walk straight through the fort's interior quadrangle. As you exit the rear archway, turn around to face the fort and set up your tripod on the steps leading out to the parade grounds. This shot is all about symmetry. Place the center of the arch in the middle of the frame, and you'll have mirrored elements of grass, pavement, stone and brick walls, and chimneys. Placing the tripod on the steps instead of at ground level allows you to see well beyond the arch all the way back to the entrance.

Focal length 35mm; ISO 100; aperture f/8; shutter speed 1/100; June 1:32 p.m.

Getting There

Governors Island is located in New York Harbor and is open Friday through Sunday from late May to early October. A free ferry service departs hourly from the Battery Maritime Building. Take the R train to Whitehall Street-South Ferry station. Walk to the end of Whitehall Street with the Staten Island Ferry building on your right and turn left onto South Street. For more information and ferry schedules, visit www.govisland.com.

Historic officer's quarters.

 When to shoot: afternoon

Jefferson Market Garden

New Yorkers pride themselves on making great things out of small spaces. And the Jefferson Market Garden is a prime example. On less than half an acre, a local community of volunteers has created an idyllic oasis in the heart of historic Greenwich Village. With the 19th-century Victorian-style public library as a backdrop, this lovingly maintained garden features a paving-stone walkway that meanders around a central lawn. Following the path's offshoots reveals hidden nooks with wooden benches just perfect for whiling away the afternoon. The perfect antidote to a day spent hoofing it around the city, this garden is a reminder of how big-city residents can come together to create a small-town feel.

The Shot

The best views of the garden are from the pathways that branch off from the central lawn. From the street entrance, take the footpath on the right. At the second opportunity, turn right, into the rose garden. Just before the path begins to loop around the rose garden, turn around and shoot with the camera angled slightly down toward the footpath. You want to capture the slight curve of the footpath and include ample foliage on either side. Set your focus toward the middle third of the frame and shoot with an aperture of f/8 or smaller. This will create sharp focus along as much of the pathway as possible, drawing the viewer's eye into the center of the frame.

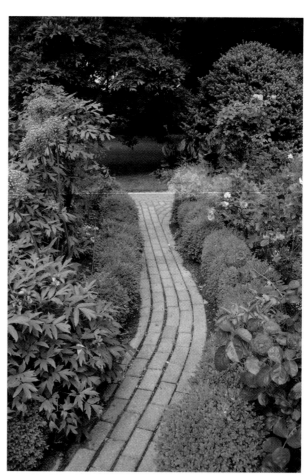

Focal length 35mm; ISO 400; aperture f/8; shutter speed 1/200; June 12:36 p.m.

The Shot

Continuing along the footpath from which you shot the last image, stop just as the bench and trellis come into view. The main subject here is the collection of roses, but if you visit around lunchtime, you're apt to find someone enjoying a moment of repose on the bench. Focus on an object in the middle of the frame and set an aperture of f/8 or greater. This should place everything except the far background and bottom-most elements in the frame into reasonably sharp focus.

Focal length 35mm; ISO 400; aperture f/10; shutter speed 1/50; June 12:36 p.m.

Getting There

The garden is located on Greenwich Avenue between Sixth Avenue and West 10th Street. It is open Tuesday through Sunday afternoons from May through October. Take the A, B, C, D, E, F, or V train to the West 4th Street station. For more information and event schedules, visit www.jeffersonmarketgarden.org.

Garden tool shed.

Prospect Park

As any true Brooklynite will tell you, the famed landscape architects Fredrick Olmsted and Calvert Vaux reached their crowning achievement when they designed Prospect Park in 1866, seven years *after* completing Central Park. With 585 acres of rolling meadows, lush woodlands, and Brooklyn's only lake, the park was designed as a rural retreat from harried city life, a place for New Yorkers to unwind from the stresses of urban living.

More than a century later, the park is an integral part of Brooklyn life, supporting a wide range of activities. Competitive cyclists race along the outer loop, which is closed to car traffic on weekends. Nature lovers enjoy walks through the recently renovated Ravine. Birdwatchers follow more than 200 species that call the park home at various parts of the year. The park serves more than seven million visitors each year and includes a zoo, a skating rink, and a bandshell that is home to the ever-popular Celebrate Brooklyn! summer series of concerts and movies. Whether you want to recharge your batteries with a walk in the woods or marvel at the grandiose architecture, Prospect Park offers a well-deserved escape from city life.

Wooded path.

The Shot

The boathouse is home to the park's Audubon Center. Built in 1905, the structure underwent a complete restoration in 2002 and enjoys a place on the National Register of Historic Places. Just across the water is a small grassy area that provides the perfect opportunity to shoot the building mirrored by its reflection. Days with little wind are best because the water will remain relatively still. You'll notice there are nine arched doorways. Set up your tripod on the grass so that the fifth doorway from the end is centered in your viewfinder. Shooting in the early evening puts the sun behind you and low in the sky. This minimizes harsh shadows on the façade and allows you to maintain detail in both the sky and the boathouse. An added bonus to shooting an hour or so before nightfall is that the lights surrounding the boathouse turn on and give off an attractive but subtle glow.

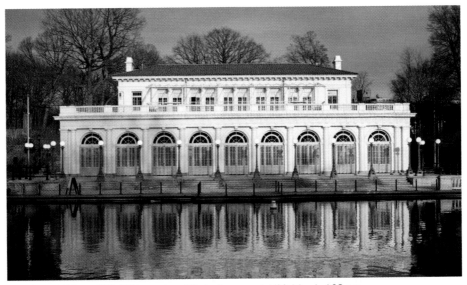

Focal length 35mm; ISO 100; aperture f/8; shutter speed 1/80; March 6:23 p.m.

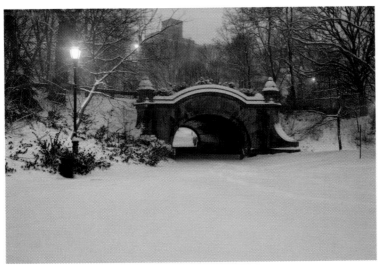

Meadowport Arch.

The Shot

The Long Meadow, at nearly a mile in length, is an enormous stretch of uninterrupted open space that is one of the most popular areas of the entire park. Surrounded by trees on all sides, most of Brooklyn's buildings are hidden from view as you scan the horizon. Use a wide-angle lens to emphasize the expanse of green. There are two main ingredients to a shot like this one—crowds and an interesting sky. Any weekend in the spring or summer with rolling clouds is a great opportunity. You'll find picnickers, sunbathers, and families at play. Set an exposure that maintains detail in the clouds while keeping the foreground relatively bright. Try to eliminate, as best you can, any worn patches of grass from your composition. You want a nice lush carpet of green spreading out into the distance.

Getting There

To reach the Long Meadow, take the 2 or 3 train to the Grand Army Plaza station. Enter at the park's main entrance and cross the paved outer loop. A small hill takes you immediately down to the northern end of the meadow.

To reach the boathouse, take the B or Q train to the Prospect Park station. Exit at Lincoln Road and walk to the end of the block to enter the park. Cross the paved outer loop, and you will see the front of the boathouse. Follow the walking path around the boathouse (keeping it on your right) and cross the footbridge to face the rear of the boathouse.

Focal length 24mm; ISO 100; aperture f/8; shutter speed 1/320; May 4:30 p.m.

Love Lane in Brooklyn Heights.

CHAPTER 5
Secret NYC

If there's one thing New Yorkers covet more than a deal, it's a secret. In a teeming metropolis of more than eight million people, any sentence starting with, "No one knows about this place yet…" is guaranteed to turn heads. In fact, New York City can have a surprisingly small-town feel once you head off the beaten path. Away from the crowds, congestion, and other tourists are lesser-known spots tucked away like precious gems. In this chapter, we'll explore an historic settlement, admire a lighthouse, enjoy some contemporary art, and visit a charming seaside community. Leave behind the New York City everyone back home knows and venture where locals revel in their own private discoveries of the city. Just don't tell anyone I told you.

Shooting Like a Pro

In most occupations, professionals work faster than amateurs. My plumber needs only minutes to repair a leak that would consume an entire weekend if I attempted the job. Travel photography is quite opposite in this regard. Think about how most people take a vacation picture. Standing with the camera at eye level, they may take a step toward or away from their subject, fire a single shot, and call it a day. Pros, on the other hand, will spend quite some time shooting from different directions, angles, and positions. You may notice them constantly adjusting the focus on their lens. Perhaps switching the camera position from horizontal to vertical. Or adjusting settings on the camera between shots. All told, pro photographers will spend much more time at a given location. Why? One word: composition. Get it right, and your images will immediately grab viewers' attention. Ignore it, and you've got photos that inspire mostly yawns.

The Gear

It's hard to shoot what you can't see. One consequence of the ever-shrinking point-and-shoot camera is that it's become more difficult to critically evaluate the composition. The tiny viewfinders on these compact models are dim and not very accurate in showing you exactly what your lens is seeing. For this reason, almost everyone uses the LCD screen to compose an image. This is instinctively like watching television, which is why most people hold the camera straight out at eye level when they shoot.

By comparison, a major benefit of a digital SLR is that its viewfinder is large and bright. You can see very clearly the elements that make up your composition. Plus, you're looking through the same optical path as the lens. When the shutter is tripped, the viewfinder actually blacks out momentarily as the viewing prism slides out of the way so light can reach the lens.

Another important feature of a digital SLR is the ability to manually adjust the focus of the lens. A high-quality viewfinder makes it easy to evaluate focus. And while most autofocus systems assume you want whatever is in the center of the frame to be sharp, you may be shooting at an angle or want to emphasize a foreground or background object that is decidedly off-center. Focus manually by turning the lens' focus ring, and you have complete control over where to draw the viewer's attention. The use of aperture to control depth of field is intricately related to focus as well. See the sidebar "The F/Stops Here" for a brief primer.

The Plan

Here's an exercise that will quickly improve your composition skills. The next time you find a subject to photograph, use what I call the *Five on Five* technique. From the moment you lift the viewfinder to your eye, count silently to five while you scan the entire frame from corner to corner. With this kind of attention to composition, you'll notice more elements in the scene, particularly along the edges of the frame. Ask yourself, "Do they enhance the image or detract from the composition?" Only after answering this question and making any necessary adjustments in composition should you press the shutter.

Once you've captured your first image, shoot the same subject from a different angle, position, or vantage point. Kneel, crouch, move to one side, aim the camera up or down. Remember to count to five before pressing the shutter. Repeat this process until you have a total of five shots. In addition to changing the composition between shots, experiment with placing focus on different areas of the image as well as switching between wide and narrow apertures.

After uploading the images and viewing them on the computer, ask yourself which of the compositions is more effective. Which angle worked best? Where was the best spot to place sharp focus? Is the background adding to or distracting from the subject? Spending this much time on a single series of shots will introduce you to the many compositional possibilities at your disposal when creating a photograph. And with practice, you'll be on your way to capturing more professional images.

THE F/STOPS HERE

Simply put, aperture controls the size of the lens opening and is expressed in f/stop numbers. An f/stop of 1 represents an extremely wide opening. An f/stop of 64, on the other hand, indicates a very narrow opening. It may seem obvious that a wider opening allows more light to reach the camera sensor or film, which means a faster shutter speed can be used for the same exposure value. But the choice of aperture has another equally important effect.

When you focus your lens on a given object, the aperture determines just how far the plane of sharp focus will extend both in front of and behind that object. Use a wide aperture to ensure that areas in front of and/or behind your focus point will blur, keeping attention directly on your subject. Use a narrow aperture to extend the range of sharp focus—known as *depth of field*—to objects in front of and/or behind your focus point. The two images of pears show just how much of a difference you can make with a change in aperture.

A wide aperture of f/1.4.

A narrow aperture of f/16.

When to shoot: dawn, morning, afternoon

Brooklyn Heights Alleyways

Nestled between downtown Brooklyn and the East River, Brooklyn Heights has long attracted the borough's wealthiest residents with cobblestone streets, 19th-century mansions, and amazing views of lower Manhattan. But there's more to this neighborhood than $10,000-a-month rentals. It was here that the Dutch first staked their claim to Brooklyn in the 17th century. Walt Whitman published his first edition of *Leaves of Grass* here. Robert Fulton set sail the first commercial steamboat operation from this shore. With its rich history, this neighborhood was the first in the entire city to be designated an Historic District by the Landmarks Preservation Commission, placing strict limits on renovation and new construction. A stroll down almost any street is guaranteed to take you past lovingly maintained brick and brownstone residences that epitomize a variety of early architectural styles. But two of this community's jewels have to be College Place and Grace Court Alley. In each of these quiet, dead-end side streets, you'll find immaculate carriage houses and converted stables that transport you back to the era of horse-drawn carriages and gas-lit street lamps.

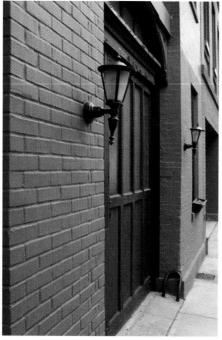

Carriage house on College Place.

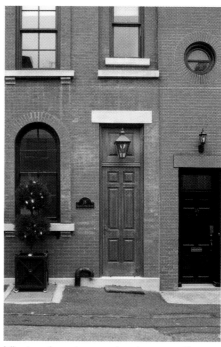

Nineteenth-century carriage house on Grace Court Alley.

The Shot

There are only four of these two-story carriage houses at the end of this alley. The key to this shot is framing it so that the houses seem to stretch all the way to the horizon, elongating the perspective. There's very little room to back up in this part of the alley, so a wide-angle lens is a must. Shoot at a 45-degree angle to the houses. This creates leading lines along the base of the doorways and the top of the arches. The first and last house offer matching bookends of natural brick, contrasting with the painted exteriors. An aperture of f/8 keeps focus relatively sharp between the foreground and background. This aperture requires a slower shutter speed, so a tripod is necessary. Overcast days provide soft, even light with no shadows being cast across the facades. When the weather calls for clear skies, one alternative is to shoot at dawn, before the sun has risen high enough to cast shadows. If you shoot during hours when the street lamps are on, you may need to override your camera's auto exposure setting to retain detail in the highlights.

Focal length 20mm; ISO 100; aperture f/8; shutter speed 1/10; March 7:44 a.m.

The Shot

The two central buildings in this picture are contemporary renovations of the original, and much less grand, carriage house and garage. Because of the block's landmark status, the new work had to retain a compatible style. The setup for this shot is fairly simple. Three things you need, though, are a tripod, a bubble level, and an ultra wide-angle lens. A 14mm lens lets you capture all three sides of this alley. Use a bubble level and place it in the hotshoe of the camera. Then align the tripod's head along both the horizontal and vertical axes until it is perfectly level. There's simply no way to reliably accomplish this when shooting handheld. And if the camera is not level, the lines of the building will not be straight. As in the previous image, overcast days are perfect for this kind of shot.

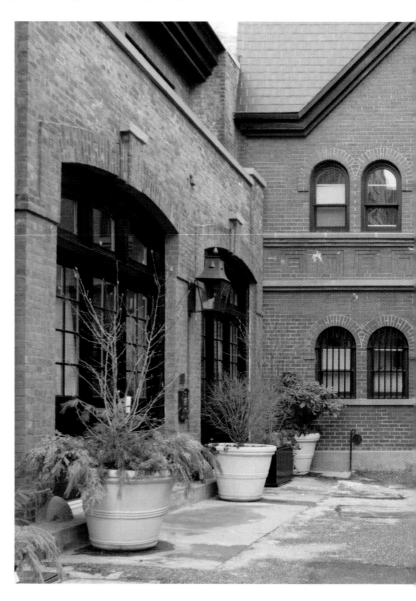

Getting There

To reach Brooklyn Heights, take the 2 or 3 train to the Clark Street station.

To get to College Place, exit at Henry Street. Walk south on Henry Street one block and turn right onto Love Lane. Follow Love Lane halfway down the alley and turn right onto College Place.

To get to Grace Court Alley, exit the subway station at Clark Street and walk one block west to Hicks Street. Make a left on Hicks Street and walk three blocks, crossing Remsen Street. Once past Remsen, continue on Hicks Street halfway down the block and turn left into Grace Court Alley.

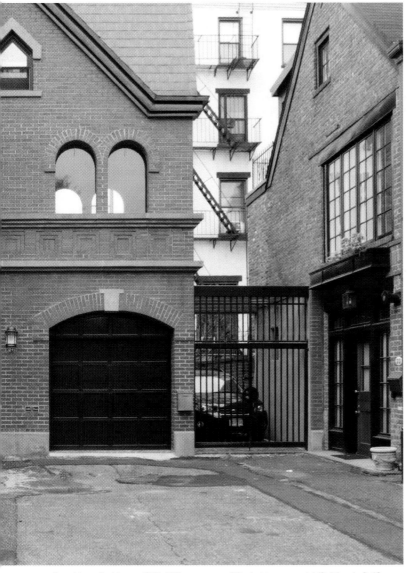

Focal length 14mm; ISO 100; aperture f/8; shutter speed 1/2; March 3:49 p.m.

When to shoot: afternoon, evening, night

City Island

For all of the images conjured up by the Bronx, it's a safe bet that yacht clubs, fishing stores, and a main drag lined with antique shops and seafood restaurants are not among them. But that's exactly what you'll find on City Island, a small seaside community located on the edge of the Long Island Sound. Established as an English settlement in 1685, the island has a long nautical history that includes shipbuilding and sailing. Today, a stroll along City Island Avenue offers a staggering choice of seafood restaurants. Indeed, that is the town's biggest draw on summer weekends, with traffic often bumper to bumper as residents from mainland Bronx head to dinner. For a better sense of the lives that locals lead, head down any of the side streets to see New England–style houses that quickly make you forget you're still in New York City.

The Shot

You can't come away from City Island without a shot of boats. Head south along City Island Avenue past Pell Place and look for the huge Boatmax sales lot. Continue to the end of the lot and turn into the driveway. Use an ultra-wide 14mm lens. Set up your tripod in the middle of the driveway. The wide perspective of the lens enhances the size of the foreground boats. It also making those along the top appear ready to sail majestically into the night sky. Shoot at an angle so that the fence, with its colorful flags, leads the viewer through the frame. With a long enough exposure, you can get a brilliant blue sky up to a half hour or so past sunset.

Focal length 14mm; ISO 400; aperture f/5.6; shutter speed 6 seconds; July 8:59 p.m.

Wood-shingled house on Fordham Street.

New England Colonial house on Fordham Street.

The Shot

Bring home a shot of this house at the corner City Island Avenue and Ditmars Street, and you may have a hard time convincing anyone that you were in the Bronx. This charming home and front yard just beg to be photographed. Stand just outside the white picket fence, taking care not to include it in the foreground. Place the front door at the center of the composition. When shooting handheld, use the siding along the house as a guide to help keep the camera level. With so much shade from surrounding trees, the house is rather dark, and you need an exposure that lets in a good amount of light. It's important, then, to create a composition that eliminates the sky, which at this exposure would register as nothing more than a blown-out highlight.

Focal length 35mm; ISO 400; aperture f/2.5; shutter speed 1/80; July 8:10 p.m.

 Unless you have a camera with GPS capability, keeping track of where a photo was taken can be a time-consuming and often impossible chore. A low-tech yet effective solution I use is to photograph the street signs at intersections after each and every photo op. Later, when I view images on the computer sorted by capture time, the last picture in each group of images shows the street name on which I shot.

Getting There

To reach City Island, take the 6 train to the Pelham Bay Park station. Exit down the ramp and transfer to the BX29 bus for the 10-minute ride to City Island. I recommend exiting the bus at the first stop past the City Island Bridge and walking the full length of City Island Avenue (approximately 1.5 miles), where you can catch a return bus at the intersection of City Island Avenue and Rochelle Street.

The local ice cream shop.

 When to shoot: afternoon

5 Pointz

Once reviled as vandalism, yet now celebrated as an art form, graffiti remains an enduring symbol of youth culture in New York City. And 5 Pointz, located in Queens, is the city's undisputed graffiti mecca. Featuring the work of talented artists from around the world, its distinction lies in that it offers artists a legal way to express themselves on an authentic canvas—a commercial factory that spans a full city block.

Through an arrangement with the building's owner, Meres One—the man responsible for 5 Pointz and an accomplished graffiti artist—reviews portfolios and governs the location and amount of space given to each artist. Prized spots are reserved for the best work. Large, intricate designs may remain up for as long as a year, while others are painted over weekly. The skill and talent on display here is impressive, with everything from comics-inspired fantasy to photorealistic portraits.

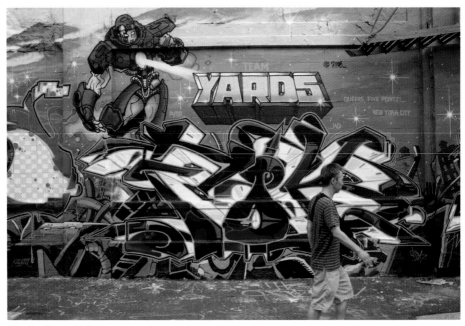

Mural with passerby.

The Shot

One way to creatively capture a one-dimensional image is to shoot from an angle. The artist painted this woman in profile, so I mimicked this by shooting at roughly a 30-degree angle from the wall. This composition directs her gaze to the upper-left corner of the frame while creating leading lines in the brick masonry that lead the viewer through the image. Shooting in a vertical format emphasizes the colorful wings by allowing them to spill out of the frame. It also creates an interesting triangle at the bottom of the image where the edge of the building meets the sidewalk.

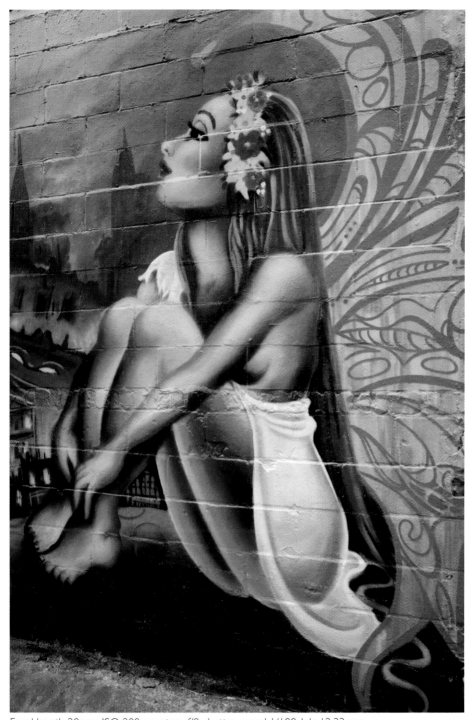

Focal length 20mm; ISO 200; aperture f/8; shutter speed 1/100; July 12:33 p.m.

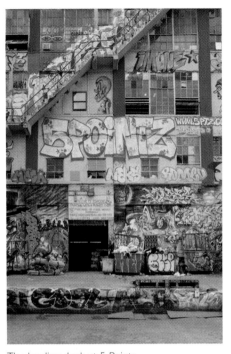

The loading dock at 5 Pointz.

Manga-inspired fantasy.

Graffiti hieroglyphs.

The Shot

This portrait of the late artist Jean-Michel Basquiat is a stunning example of a photorealistic mural style and is indicative of the high quality you'll find at 5 Pointz. The attraction here is the juxtaposition of smooth shading and subtle skin tones laid over a rough-hewn wall with layers of peeling paint. Shoot this as you would to reproduce a traditional painting, from a head-on perspective, in soft diffuse light provided by an overcast sky. I framed the shot to include only the artwork, treating the wall simply as a textured canvas. I purposely avoided the sidewalk, fire escape, and other building remnants that would dilute the power of the artwork. The small exposed section of brick in the bottom-right subtly conveys a hint of urban decay.

Focal length 20mm; ISO 200; aperture f/8; shutter speed 1/125; July 12:42 p.m.

Getting There

The 5 Pointz building is located at 45-46 Davis Street in Long Island City, Queens. Take the 7 train to the 45th Road/Court House Square station. Exit on 23rd Street and walk one block south to Jackson Avenue. Cross Jackson Avenue to Davis Street. Continue along Davis Street to enter the courtyard area.

When to shoot: evening, sunset

Little Red Lighthouse

The Little Red Lighthouse, immortalized in the 1942 children's book of the same name, was built in 1880 and has been in its current location since 1921. Standing at 40 feet tall and made of cast-iron, this is the only lighthouse in all of Manhattan. Though dwarfed by the George Washington Bridge that towers over it, the lighthouse serves as an important reminder of the city's maritime history. No longer under private ownership, the lighthouse is administered by the city's Department of Parks and Recreation. From spring through fall, they offer regularly scheduled tours providing access to the interior all the way to the top of the tower. The lighthouse is located in Fort Washington Park, where you can take full advantage of a playground, tennis courts, baseball fields, and basketball courts. Or simply enjoy a summer picnic in the grass, never far from this jewel on the Hudson River.

The Shot

The most dramatic vantage point from which to shoot is the rocky outcrop just off the footpath south of the lighthouse. Venturing out onto coastal rocks with a camera and tripod should always be done with care. Making sure the tide is low and the rocks are dry goes a long way to keeping you safe. When setting up your tripod legs, make sure they have firm contact with a stable surface before attaching your camera.

Place the lighthouse to the far right in order to capture as much of the bridge's expanse as possible. This also eliminates any features of the park. The composition here concentrates solely on the shoreline. You're going to have to override your camera's auto exposure setting. Choose an exposure that holds at least some detail under the bridge but that avoids blowing out the sky.

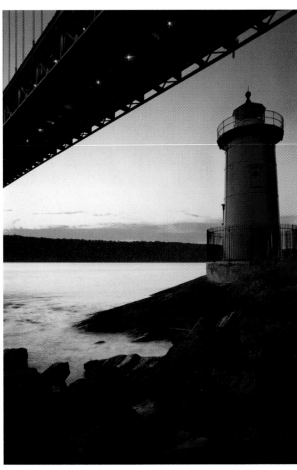

Focal length 20mm; ISO 100; aperture f/8; shutter speed 1.3 seconds; July 8:42 p.m.

The Shot

For a different interpretation of the scene, simply flip your camera to a horizontal instead of vertical format. You get a larger expanse of the bridge and crop out much of the foreground rocks seen in the vertical lighthouse image. The result is a more isolated shot with the feeling that you are actually on the water.

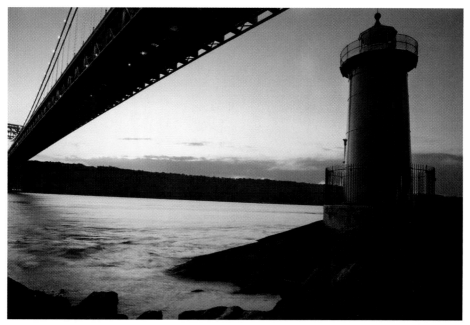

Focal length 20mm; ISO 100; aperture f/8; shutter speed 1.3 seconds; July 8:45 p.m.

Getting There

The lighthouse is located under the Manhattan side of the George Washington Bridge. Take the A train to the 181st Street station. Walk west (downhill) on 181st Street, and it becomes Plaza Lafayette. Cross the footbridge and take a left down the path under the overpass. Cross over the railroad tracks and follow the path to the left.

 No camera's auto exposure is right 100 percent of the time. Tricky lighting situations abound. Fortunately, most cameras offer an easy way to make an adjustment without going into full manual mode. Check your camera's user guide for an exposure compensation button or dial. It will go from at least a –2 to +2 setting in 1/3 stop increments. This means you can set the camera to automatically expose anywhere between two stops darker to two stops brighter than what it has calculated as the correct exposure.

When to shoot: afternoon, evening, sunset

Red Hook Waterfront

Mention the name Red Hook, even to lifelong New Yorkers, and you can easily draw a blank stare. The area has no subway access. It's surrounded by water on three sides and cut off on the fourth by a highway overpass. Visitors don't just "happen by" the area. A pity,

because this post-industrial neighborhood in South Brooklyn combines a rich history with small-town quirkiness and offers some of the most spectacular waterfront views in the city. Dominated by Civil War–era warehouses, the waterfront section of Red Hook—referred to by locals as "the Back"—was once one of the busiest shipping ports in the country. An exposé on the harsh and corrupt dock life here during the 1950s was the inspiration for Elia Kazan's film, *On the Waterfront*. While the mobsters are gone, the historic buildings remain, some of which have been renovated for office space. And you're not exactly in the hinterlands, with bakeries offering Wi-Fi access, a Fairway supermarket, and most recently, an IKEA superstore. The Louis Valentino, Jr. Pier looks out across the New York Harbor with a direct view of the Statue of Liberty, a sunset-perfect scene if there ever was one.

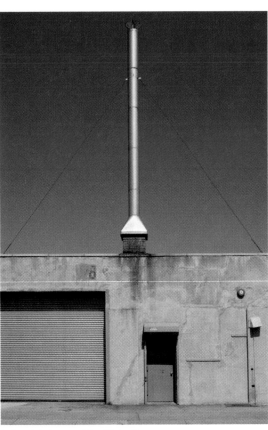

Industrial shop on Van Dyke Street.

The Shot

My rule of thumb as a photographer is that when you pass a house with a giant fish head *and* a tricycle protruding from the wall, you've got to take a picture. I'll admit that so far, this house at 26 Reed Street is the only one I've come across. The best time to shoot it is at night. Stand directly across the street on the sidewalk in front of the Fairway parking lot. The clear blue sky offers great background for the building's bric-a-brac style. Make sure to wait for the street lamp just to your right to turn on for the evening. It offers perfect directional lighting for the building, and the warm temperature of the light contrasts nicely with the night sky. You'll be using a long exposure here, so a tripod is mandatory.

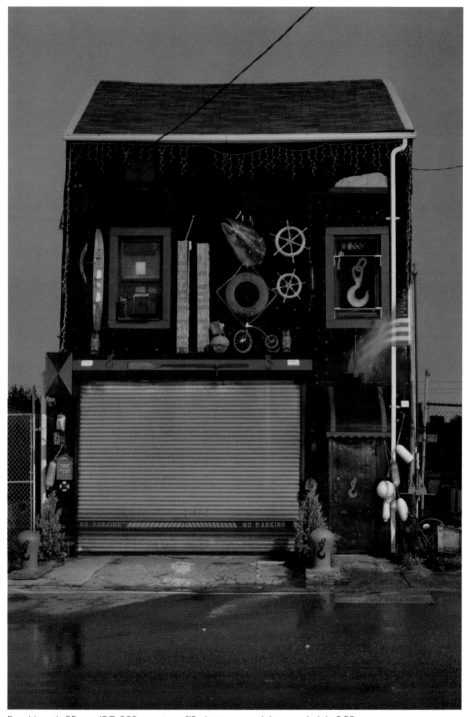

Focal length 35mm; ISO 200; aperture f/8; shutter speed 6 seconds; July 8:53 p.m.

The Shot

This rusted trolley car is situated just behind the Fairway supermarket. The Don Quixote-esque vision of transit buff Bob Diamond led him to purchase these relics with the hope of restoring trolley service to Red Hook. Plans and financing fell through, but two of his cars remain in all their decaying glory. In the bright, harsh light of day, a rusted-out trolley car holds little appeal. But just after nightfall, with the warm glow of streetlights coming through its windows, this trolley car comes to life. Get low and shoot at a 15-degree angle from the side of the car. The low vantage point lets the subject fill most of the frame. The angle creates leading lines, which draw the viewer from the top left of the frame to the bottom right. A very long exposure is required to capture sufficient detail and bring out the remaining blue in the sky.

Focal length 35mm; ISO 400; aperture f/22; shutter speed 30 seconds; April 7:53 p.m.

Getting There

To reach the waterfront, take the A, C, F, 2, 3, 4, or 5 train to the Jay Street/Borough Hall station. Exit at Jay Street. At the corner of Jay Street and Willoughby, catch the B61 bus to Red Hook. Get off at the last stop.

To reach the trolley cars, walk south on Van Brundt to the water's edge. They are located directly behind the Fairway supermarket. To reach 26 Reed Street, start from the front entrance of the supermarket and walk to the street at the far end of the parking lot.

Sunny's Bar on Conover Street.

Sunset on the Valentino Pier.

 When using a tripod, resist the urge to simply plant it in a convenient spot and start shooting. Instead, grab your camera and walk around the subject before committing to a spot. Examine different locations, vantage points, and angles in the viewfinder. Once you've found the perfect composition, go get the tripod and set it up right there.

When to shoot: afternoon, evening

Socrates Sculpture Park

The Socrates Sculpture Park is the result of a successful partnership between artists, community residents, and the city's Parks department. As recently as 1985, this site was nothing more than an abandoned landfill where illegal dumping was the primary activity. Today, in addition to being a public park with waterfront views across the East River, it is a renowned outdoor museum that provides a venue for emerging sculptors. New exhibitions go up every spring, and there are countless cultural events held throughout the year, including a popular outdoor cinema series. The park is located in the heart of Long Island City, which is quickly becoming the next big art scene for New York hipsters. Only minutes from Manhattan, the neighborhood's newfound cachet is anchored by the presence of the P.S. 1 Contemporary Art Center as well as Silvercup Studios, where hit shows such as *The Sopranos* and *Sex and the City* were filmed.

The Shot

This sculpture, a carved stone by Michael Mercil, is photographed with the park in the background, giving a sense of the relationship in scale between the sculpture and its surroundings. Shooting from a vertical position echoes the shape of the sculpture itself. The weed growing in front of the artwork serves as a perfect complement to the vertical composition. Shooting in the late afternoon when the sun is casting long shadows adds relief to the piece's rising spiral without creating highlights completely void of detail.

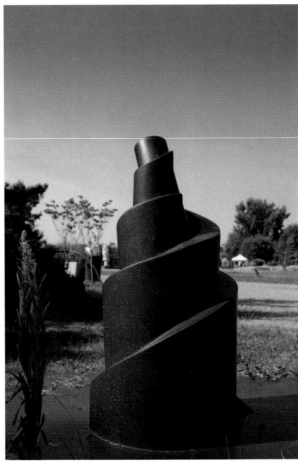

Focal length 35mm; ISO 100; aperture f/8; shutter speed 1/250; July 4:59 p.m.

The Shot

This work, by artists Jade Townsend and Michael Petersen, uses reclaimed materials from an actual set for a photo shoot. This half-buried surburbia is a compelling object to photograph in this natural environment. I did two things to make the composition as appealing as possible. I used a wide-angle lens and shot from close range, only a couple of feet in front of the picket fence. Then I crouched down to shoot near ground level. In this way I exaggerated the scale of the objects and eliminated any visual cues of the park's setting. The whimsy of the sculpture is emphasized. When shooting at such close range, the placement of focus is crucial. By setting focus on the picket fence with an aperture of f/8, I was able to emphasize the form and lines in the foreground object. The house facades, though not tack sharp, are clearly recognizable and add a sense of depth by clearly delineating the space between foreground and background.

Focal length 35mm; ISO 100; aperture f/8; shutter speed 1/250; July 4:52 p.m.

Getting There

Socrates Sculpture Park is located at 32-01 Vernon Boulevard in Long Island City, Queens. Take the N train to the Broadway station in Queens and walk east (toward the water) for eight blocks along Broadway.

 When to shoot: afternoon

Sylvan Terrace

Built in 1882, this block of wooden two-story homes serves as a testament to the city's strong conservation efforts of recent decades. These houses are part of the Jumel Terrace Historic District. The cobblestone street leads directly to the Morris-Jumel Mansion, which holds the distinction of being Manhattan's oldest surviving house, as well as temporary headquarters for George Washington during the American Revolution. In more recent history, the Sylvan Terrace houses were subjected to decades of contemporary renovations. Many façades were covered with stucco, metal siding, or imitation brick. The Landmarks Preservation Commission led an effort in 1981 that restored the houses to the original French Colonial style you see today.

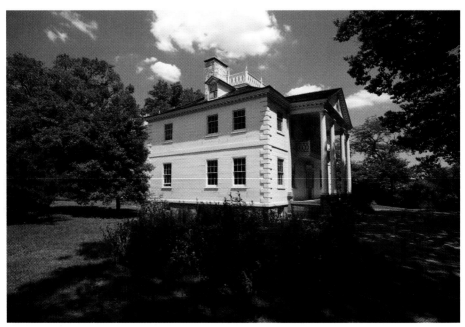

The Morris-Jumel Mansion.

The Shot

This detail that makes this shot a keeper is the old-style lamppost. Including it and a sliver of the cobblestone street in the lower right brings to mind 19th-century New York. The problem is the decidedly contemporary No Parking sign attached to the lamppost. Stand in the street at roughly a 30-degree angle to the lamppost, adjusting your position until the column completely obscures the parking sign from view. Everything else in the image falls into place. Using a 35mm lens, you can get fairly close to the sidewalk and still include the outside steps, window shutters, and molding, plus the ground-level exposed brickwork. Concentrate on keeping the camera level so that the lamppost remains vertical and does not lean toward or away from the camera.

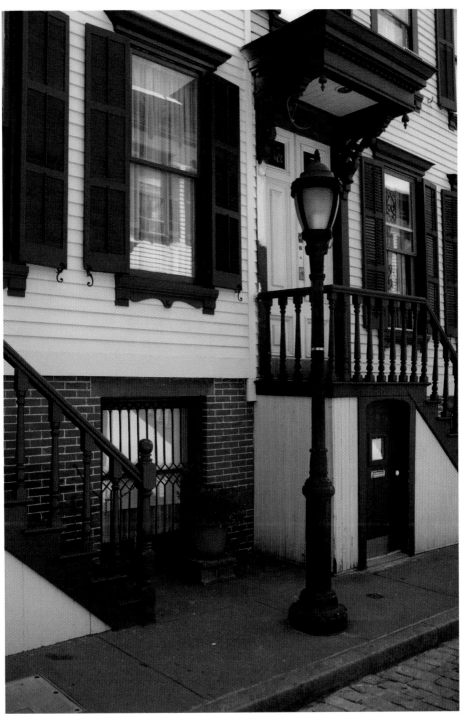

Focal length 35mm; ISO 100; aperture f/5; shutter speed 1/200; July 1:50 p.m.

The Shot

This seemingly straightforward shot requires a careful eye for a balanced composition. Set up your tripod on the opposite side of the street from No. 14 Sylvan Terrace with a wide-angle lens. Use a bubble level and adjust the camera so it's level on both the horizontal and vertical axes. You want the front door in the center of the frame while also including at least part of the neighboring staircases. The important part is to make sure the camera lens is perpendicular to the front door. If you simply rotate the tripod head to place the door in the center of the frame, the building becomes distorted. The houses are built on a hill, so the expanse of cobblestone in the foreground will decrease a bit toward the right edge of

the image. Frame your composition with a healthy amount of the street in the foreground. This makes the slope less noticeable.

Getting There

To reach Sylvan Terrace, take the C train to the 163rd Street/Amsterdam Avenue station. Exit the station and walk south on Amsterdam Avenue to 161st Street. Turn left on 161st Street and cross St. Nicholas Avenue. Midway down the block on the east side of the street, you'll see a stone wall with steps leading up to Sylvan Terrace.

Focal length 20mm; ISO 100; aperture f/7.1; shutter speed 1/80; August 4:20 p.m.

When to shoot: afternoon

Weeksville Houses

The four houses that greet you upon entering the Weeksville Heritage Center are significant for more than their 19th-century architectural style. These are the only remaining domestic structures from what was a thriving independent African American community that encompassed a seven-block radius in Central Brooklyn. Founded by free African Americans just after the Civil War, Weeksville quickly grew into a community of national significance. Home to its own schools, churches, and black-owned businesses, Weeksville's residents were successful doctors, teachers, and tradesmen at a time when the majority of African Americans were still enduring indentured servitude in the South. The goal of the Weeksville Heritage Center is to document, preserve, and interpret the experiences of this resilient community. To that end, extensive restorations were completed in 2005, which opened the houses to the public for the first time. Currently, daily tours showcase authentic period interiors and furnishings representing life for the community's residents in the 1870s, 1900s, and 1930s. The houses are a designated New York City Landmark and are on the National Registry of Historic Places.

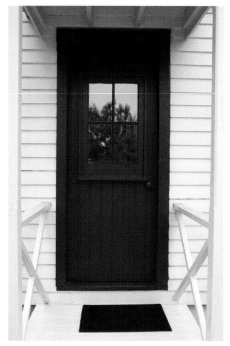

Front entrance of 1704 Bergen Street.

View from the backyard.

NOTE

Photography is not permitted inside the houses. But taking a tour of the interiors will give you a deeper understanding of the site's history and significance.

The Shot

This two-story house dates back to 1883. The most compelling shot is from the backyard. Stand near the base of the tree and shoot from a low position to include as little of the contemporary buildings across the street as possible. The overhanging tree on the right and the brown clapboard house on the left both serve as nice bookends to draw the viewer's attention to the primary subject. The wooden chair adds a nice color contrast against the green grass.

Focal length 35mm; ISO 200; aperture f/8; shutter speed 1/500; July 3:07 p.m.

The Shot

The two-family home occupying 1702-04 Bergen Street is thought to be the oldest of the surviving buildings, dating back to approximately 1840. Shooting from outside the front gate, you are directly facing the afternoon sun. Get close enough to the building so that you eliminate any sky from the composition. During visiting hours the sky will be much too bright to record as anything other than solid white with no detail. Use the gutter along the edge of the roof to make sure your camera is level.

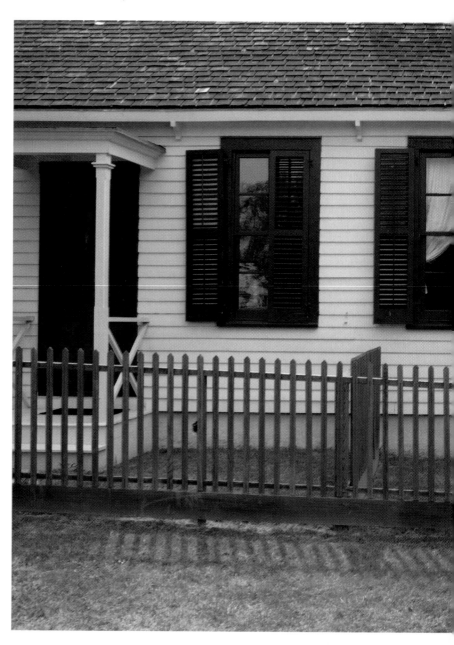

Getting There

The Weeksville houses are located at 1698 Bergen Street in Brooklyn. Take the A or C train to the Utica Avenue station. Walk four blocks south on Utica Avenue to Bergen Street. Turn left on Bergen Street and continue one and a half blocks to the site's entrance. Visit www.weeksvillesociety.org for more information, including tour hours and admission.

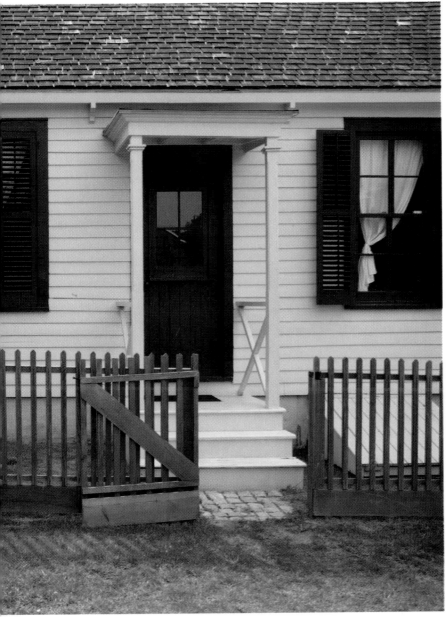

Focal length 35mm; ISO 100; aperture f/8; shutter speed 1/100; July 3:36 p.m.

Pedicabs at Columbus Circle.

Photo Opportunities According to Weather and Time of Day

I n this appendix I've listed all of the photo opportunities according to the weather conditions and time of day that yield the most pleasing images. You can use this as a quick reference when planning each day's itinerary. Events are followed by the month in which they occur. All opportunities are followed by the page number in parentheses.

 Sunny Day

 Partly Cloudy Day

5 Pointz (174)

Battery Park City (126)

Brighton Beach (44)

Bronx Zoo (130)

Brooklyn Bridge (4)

Brooklyn Heights Alleyways (166)

Bryant Park (48)

Central Park (134)

Cherry Blossom Festival
April or May (88)

Chinatown (52)

Chinese Scholar's Garden (138)

Chrysler Building (8)

City Island (170)

The Cloisters (140)

Coney Island (56)

Conservatory Garden (144)

DanceAfrica
May (92)

Elevated Acre (148)

Empire State Building (10)

Flatiron Building (14)

Flea Markets (60)

Governors Island (152)

Grand Central Terminal (16)

Greenwich Village (64)

IAC Building (18)

Jefferson Market Garden (156)

Lever House (22)

Little Red Lighthouse (178)

Mayor's Cup Handball Tournament
July (96)

Music Under New York (68)

New York City Marathon
November (100)

New York International Auto Show
March (104)

The Plaza (24)

Prospect Park (158)

Red Hook Park (70)

Red Hook Waterfront (180)

Skyline (26)

Socrates Sculpture Park (184)

Statue of Liberty (30)

Supreme Courthouse (32)

Sylvan Terrace (186)

Tango in Central Park (72)

Times Square (76)

Tugboat Race
August (108)

U.S. Open
August/September (110)

Union Square (80)

Village Halloween Parade
October (114)

Weeksville Houses (190)

West Indian Carnival Parade
September (118)

Woolworth Building (34)

 ## Overcast Day

 ## Rainy Day

Dawn Shoot

Brooklyn Heights Alleyways (166)

Central Park (134)

Flatiron Building (14)

Lever House (22)

The Plaza (24)

Skyline (26)

Supreme Courthouse (32)

Woolworth Building (34)

Morning Shoot

Bronx Zoo (130)

Brooklyn Heights Alleyways (166)

Cherry Blossom Festival
April or May (88)

Mayor's Cup Handball Tournament
July (96)

Music Under New York (68)

New York City Marathon
November (100)

New York International Auto Show
March (104)

Tugboat Race
August (108)

U.S. Open
August/September (110)

Afternoon Shoot

5 Pointz (174)

Battery Park City (126)

Brighton Beach (44)

Brooklyn Bridge (4)

Brooklyn Heights Alleyways (166)

Bryant Park (48)

Central Park (134)

Cherry Blossom Festival
April or May (88)

Chinatown (52)

Chinese Scholar's Garden (138)

Chrysler Building (8)

City Island (170)

The Cloisters (140)

Coney Island (56)

Conservatory Garden (144)

DanceAfrica
May (92)

Elevated Acre (148)

Flea Markets (60)

Governors Island (152)

Grand Central Terminal (16)

Greenwich Village (64)

IAC Building (18)

Jefferson Market Garden (156)

Mayor's Cup Handball Tournament
July (96)

Music Under New York (68)

Prospect Park (158)

Red Hook Park (70)

Red Hook Waterfront (180)

Skyline (26)

Socrates Sculpture Park (184)

Statue of Liberty (30)

Sylvan Terrace (186)

U.S. Open
August/September (110)

Union Square (80)

Weeksville Houses (190)

West Indian Carnival Parade
September (118)

Woolworth Building (34)

Evening Shoot

Battery Park City (126)

Brighton Beach (44)

Bryant Park (48)

Central Park (134)

Chinatown (52)

Chrysler Building (8)

City Island (170)

Coney Island (56)

Conservatory Garden (144)

DanceAfrica
 May (92)

Flatiron Building (14)

Grand Central Terminal (16)

Greenwich Village (64)

Lever House (22)

Little Red Lighthouse (178)

Music Under New York (68)

Prospect Park (158)

Red Hook Waterfront (180)

Socrates Sculpture Park (184)

Statue of Liberty (30)

Tango in Central Park (72)

U.S. Open
 August/September (110)

Union Square (80)

West Indian Carnival Parade
 September (118)

Sunset Shoot

Empire State Building (10)

IAC Building (18)

Little Red Lighthouse (178)

Red Hook Waterfront (180)

Skyline (26)

Supreme Courthouse (32)

Night Shoot

Brooklyn Bridge (4)

City Island (170)

Empire State Building (10)

Flatiron Building (14)

Greenwich Village (64)

Skyline (26)

Times Square (76)

Village Halloween Parade
 October (114)

Flowers at the Greenmarket.

Index